# GLOUCESTER
## THROUGH TIME
### Rebecca Sillence

AMBERLEY PUBLISHING

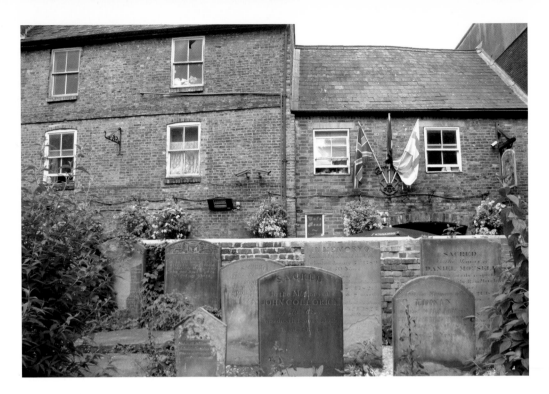

**Café René in Marylone (St Mary's Lane)**
This view was taken over the wall of St Mary de Crypt churchyard. The René was a popular 'watering hole' for students when I was in college and was the first pub in the county to be allowed twenty-four-hour opening. It has a long and interesting history, and the bar area includes a Roman well. It also hosts an annual Rhythm and Blues festival.

*This book is dedicated to my husband, Richard, and to my parents.*
*Thank you for all your support.*

First published 2011

Amberley Publishing
The Hill, Stroud
Gloucestershire, GL5 4EP

www.amberley-books.com

Copyright © Rebecca Sillence, 2011

The right of Rebecca Sillence to be identified as the Author of this work has been asserted in accordance with the Copyrights, Designs and Patents Act 1988.

ISBN 978 1 4456 0483 1

British Library Cataloguing in Publication Data. A catalogue record for this book is available from the British Library.

Typeset in 9.5pt on 12pt Celeste.
Typesetting by Amberley Publishing.
Printed in the UK.

# Introduction

Throughout history change has always fascinated us. Perhaps because of its inescapable nature or maybe just because our memories are so interwoven with how we experience our surroundings. But is it the buildings that make a place, or the people who inhabit them, and can we ever truly separate the two?

This book is an exploration of Gloucester over time, and I aim to illustrate the transformation of the city over the last century through the comparison of old photographs with modern recreations of similar views. These old photographs provide a rare opportunity to see our streets as they were and via this unique window on history you are invited to observe the changing face of Gloucester's streets and explore the lives of the people who lived and worked there. Seeing these old photographs juxtaposed with modern images in this way also highlights the subtler changes that occur over the years, which we barely notice at the time.

The story of Gloucester has always been one of transition and, as an important crossing place on the River Severn, Gloucester has hosted many famous people and events over the years. Its rich and varied history is reflected in much of the surrounding architecture and each building and street tells a story of its own, making it a popular location for tourists and film crews alike.

This book follows the same layout as the city itself and is divided into four chapters that focus on each of the main gates and outlying areas. The photographs mainly run in sequence along the streets so that each section might be walked in order. As I guide you through Gloucester's streets I hope to bring to life some of its famed history, but also give an insight into the everyday Gloucestrians of the past.

I was born and educated in Gloucester and the city has always played a part in my life. Whenever I visit I am fascinated by the history that surrounds me, and the sheer diversity of that history; spanning centuries, from Roman walls to Medieval cathedrals, from Victorian warehouses to the glass and concrete of today.

The story of Gloucester is now set to change again, this time by regeneration. Empty buildings stand awaiting demolition, ready to make way for a new century of flats, offices & designer outlets. But this time efforts have been made to preserve our heritage. As I sit writing these final few paragraphs I can see the distant spires of the Cathedral from my bench by the docks. Students with iPods wander through the ruins of an ancient priory; here, the old and new meet in curious harmony. It is a panorama of ancient, modern, rural and industrial; the water ever-flowing in this riverside city from its Roman beginnings until today.

Change has happened more rapidly in the last century than ever before but whether we look upon these changes as progress, or with a wistful nostalgia, I shall leave up to the reader to decide.

Rebecca Sillence

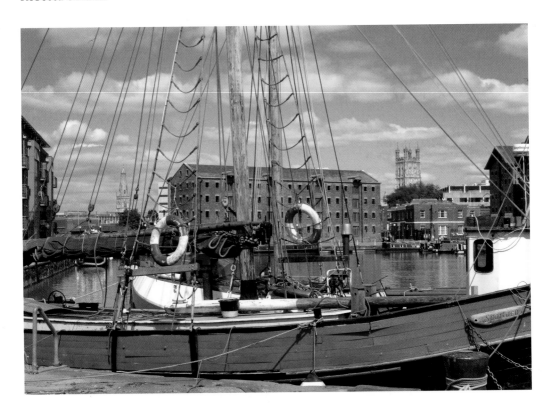

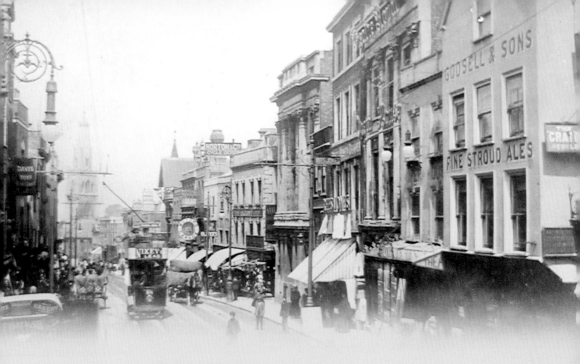

# CHAPTER 1

# Westgate Street

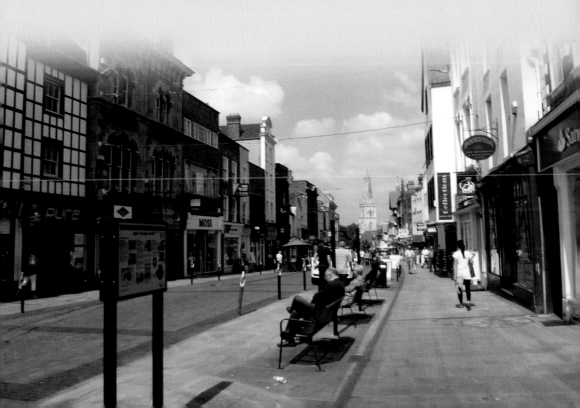

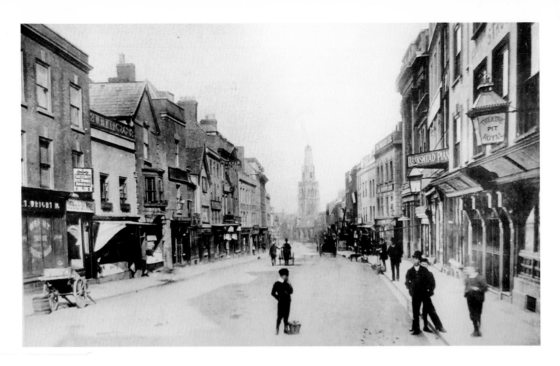

## Westgate Street

Westgate Street is home to Gloucester's famous Cathedral and leads from the town centre to the River Severn. The photograph above shows a view looking west in 1850. To the right-hand side you can see where the Theatre Royal stood, which was allegedly haunted by the ghost of actress Eliza Johnson. The building next door was owned by Godsell & Sons and was home to the Theatre Vaults pub between 1799 and 1958.

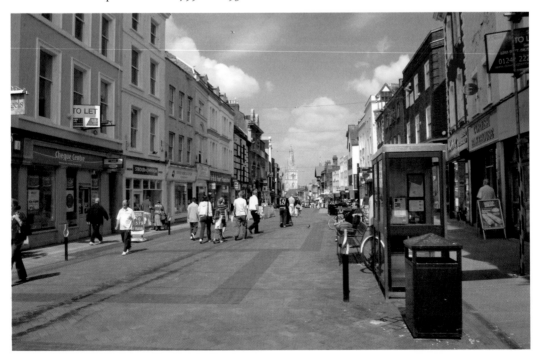

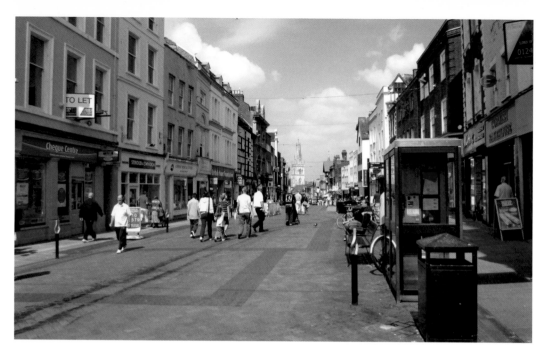

Towards the Cross
In this view of Westgate Street looking towards the Cross, the printing works are just visible to the right-hand side. A tram advertising Talbots Mineral Water can be seen approaching in the distance. Note the gentlemen wearing straw boaters in the foreground to the left of this image.

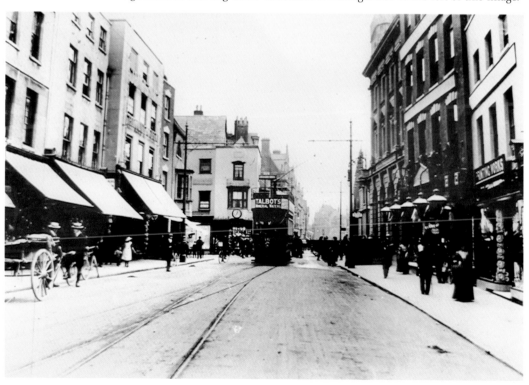

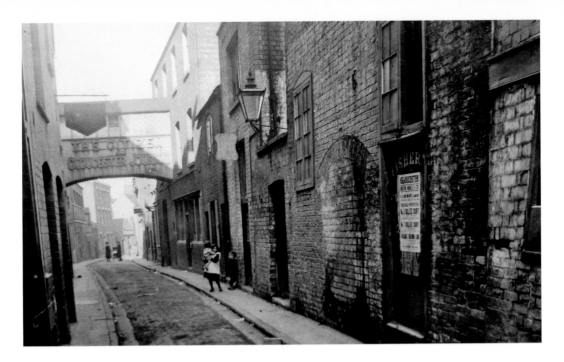

## St John's Lane

St John's Lane is a small alley leading off of Westgate Street, which contains a handful of independent shops and is easily recognised by the wrought-iron arch bearing the logo of the *Citizen* newspaper. The *Citizen* was established in 1876 by Samuel Bland and later joined forces with the *Gloucester Journal*, which was founded much earlier in 1722 by Robert Raikes and William Dicey. St John's Hall used to stand where the present day M&S is located. As you can see in the photograph above, a bridge once linked it to the building opposite, which was home to the *Citizen* for many decades.

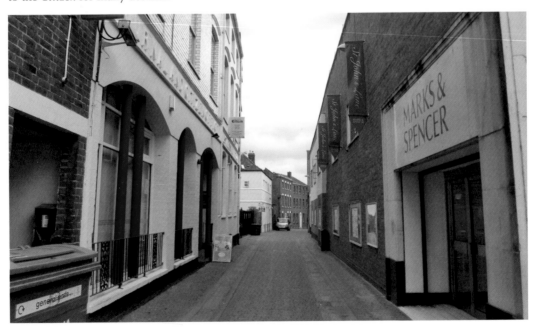

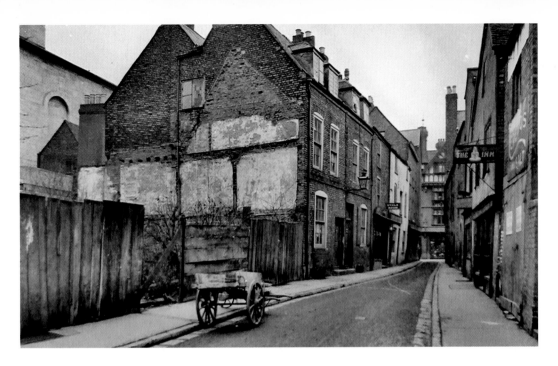

### Berkley Street

Previously known as Broadsmith Street, Berkley Street has changed significantly since this photograph was taken. The Fountain Inn to the right of the photograph was known as Savage's Inn during the 1400s and later the Catherine Wheel Inn. Having heard of Jacobite rebels holding meetings in the pub, King William III is said to have ridden his horse up the stairs to their meeting room to show his contempt. The buildings to the left were demolished to make way for the extension of Shire Hall.

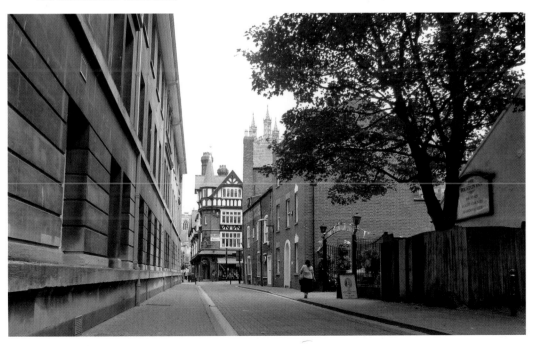

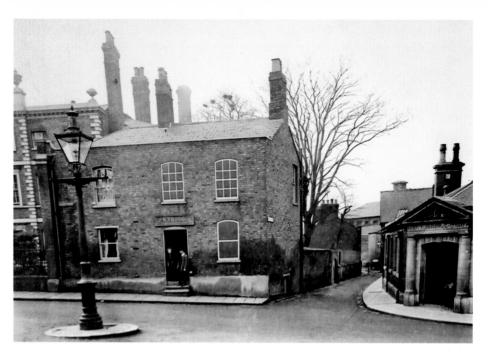

## Trigg's

Beyond Berkley Street lies the area known as Bearland. Whilst it's traditionally considered part of Southgate Street, I recommend that the reader explores Bearland here and then returns to Westgate Street via Bull Lane. This photograph from 1912 shows Trigg's, the carpenter and joiner, just prior to demolition. The building was pulled down to way for Bearland Fire Station. To the right of the photograph you can see the Petty Session Court on the corner of Barbican road, which is now the back of the Police Department.

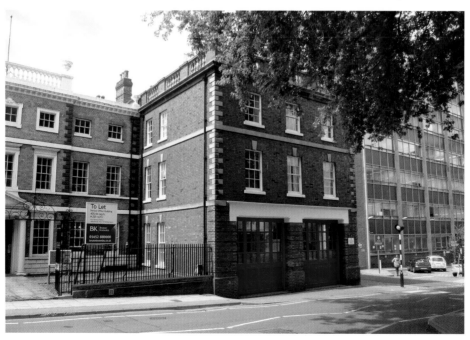

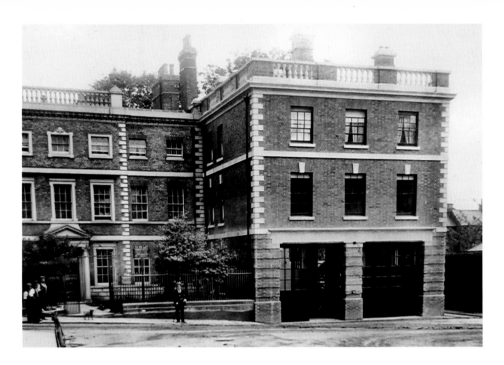

## Bearland Fire Station

The photograph above shows Bearland fire station just after it was completed in 1913. The newly formed City Brigade replaced the private horse-drawn brigades of the insurance companies who disbanded in 1912. This building functioned as the centre of fire control until 1956 when operations moved to a new station in Eastern Avenue, pictured below. A change of premises is scheduled again to stations being built in Churchdown and Tuffley.

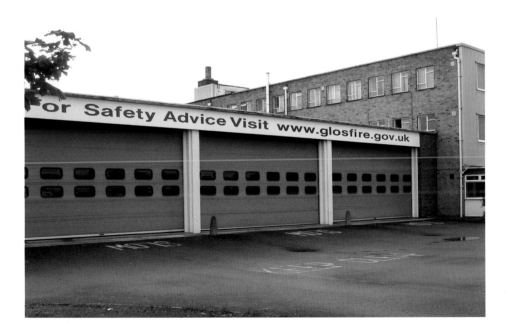

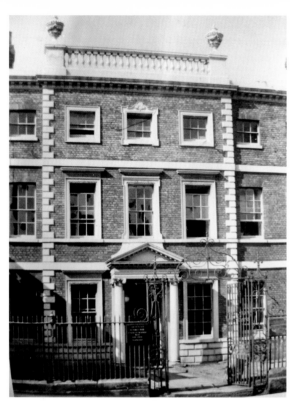

### Bearland House

Gloucester attorney William Jones built Bearland House in the 1740s. The surrounding land of the Bearland estate was gradually developed during the nineteenth century and today it's hard to believe it once consisted of formal gardens and orchards. Bearland House has been used for many varied functions over the years, including housing the High School for Girls in the early 1900s and the Gloucester HQ for the post office telephone service for over fifty years.

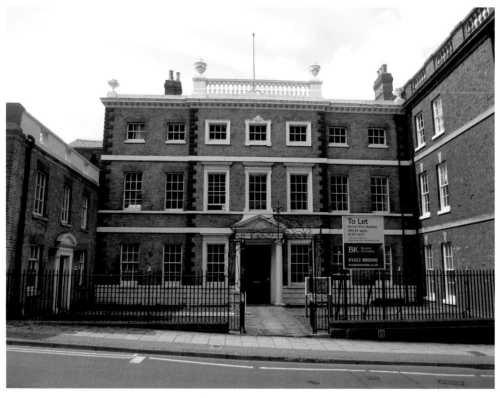

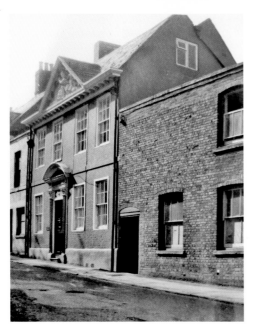

## Bearland Lodge

Built in the eighteenth century, Bearland Lodge boasts an interesting triangular pediment above the doorway, depicting Minerva, the goddess of wisdom. It was probably added to the lodge from nearby Ladybellegate House. By the front door of the lodge some of the changes not often captured in photographs can be observed. For example, the old-style metal bins look rather different from the rows of wheelie bins that now fill the streets on waste collection day, and the pram left outside is much larger than the compact models popular today.

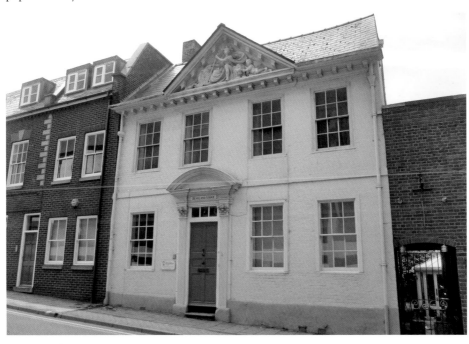

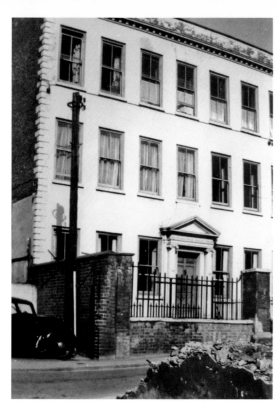

### Ladybellegate House

Flanked by two rather grey and uninspiring buildings, Ladybellegate House makes for an impressive sight. Built by Henry Wagstaffe in the early 1700s, the property was later occupied by the Raikes family, Gloucester Liberal Club, and was at one time used as a health centre. The building was sold to the Gloucester Civic Trust and reopened in 1979 following extensive renovation.

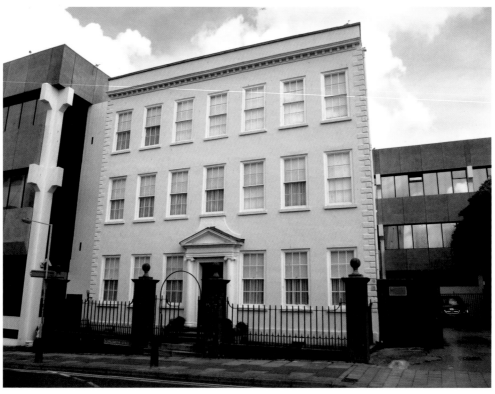

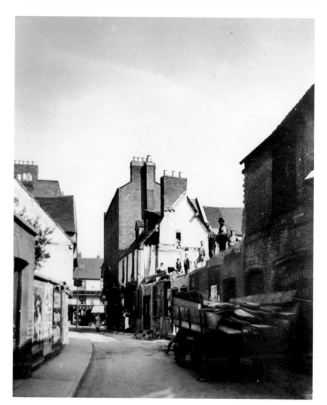

## Longsmith Street

Longsmith Street was the centre of medieval iron production in the city. It takes its name from this trade but has also been known as Old Smith Street, Bolt Lane and School House Lane. In the above photograph the row of workmen standing on the roof are demolishing some of the cottages on the right side of the street. To the left of the modern image you can see the edge of the Longsmith multi-storey car park.

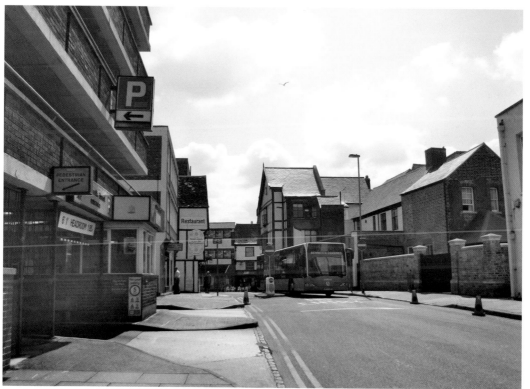

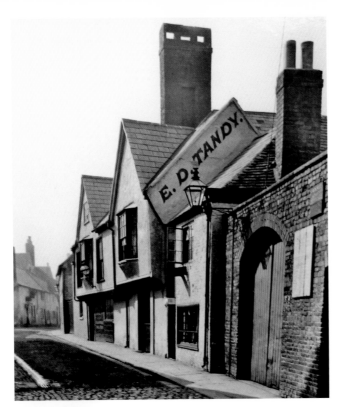

## Bull Lane

Bull Lane most likely takes its name from the pub that once stood there. However, it was once known as Gore Lane due to the presence of pig slaughterhouses. The Bull Inn dated from at least the 1680s but probably even earlier and was a pub until 1910. It became an antiques warehouse for a time and was finally demolished in 1952 to make way for the Telephone Exchange. When this photograph was taken the pub was owned by E. D. Tandy, and to the left of the new image below you can see the gates that lead to the side of the Fleece Inn.

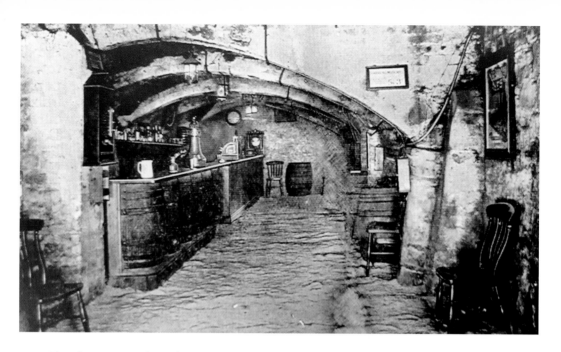

### The Fleece Inn and Monks Retreat

The Fleece Inn was one of the 'Great Inns' built by St Peters Abbey. Originally called the Golden Fleece, this building dates from the late fifteenth century and was created to accommodate pilgrims visiting the tomb of King Edward II. Gracie Fields and Margaret Thatcher both stayed at the Fleece, and the twelfth-century vaulted crypt below is described as the finest example of its type in Northern Europe. The Fleece shut in 2002 and has been vacant for some years.

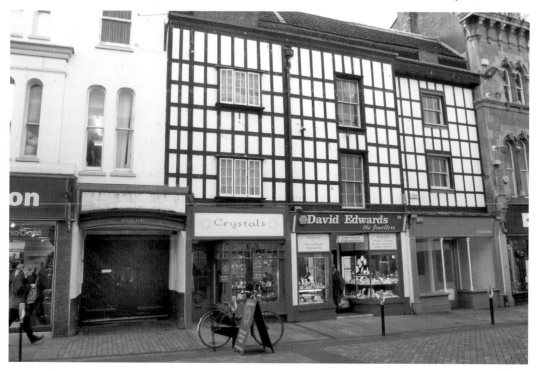

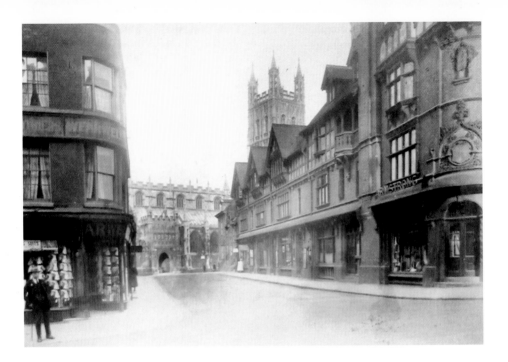

## College Street

On first impressions this view of College Street has changed very little; however, on closer inspection it becomes apparent that some architectural changes have occurred. For example, the gentleman's outfitter's building on the left-hand corner no longer mirrors the curved edge of the building opposite. Pedestrian archways nearby King Edward's Gate were added in the 1980s, and central gates were installed to provide vehicular access to the Cathedral in 1992.

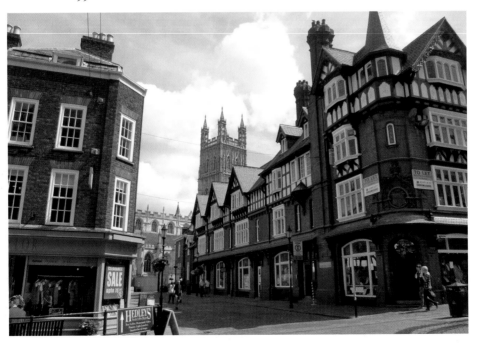

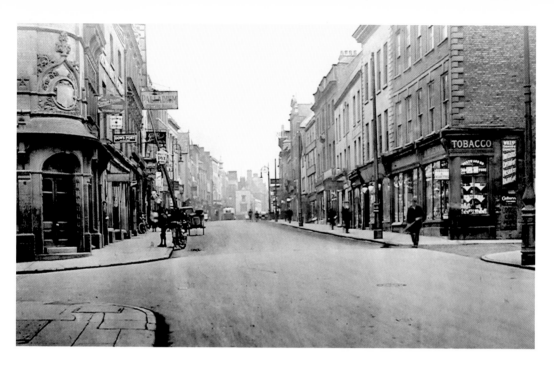

### College Street to the Cross

This view was taken looking towards the cross from the entrance of College Street. The tobacconist's shop to the right marks the corner of Berkley Street. To the left of the image above you can see a sign for the Palladium Picture House and the image below shows a very similar scene today, with the addition of a modern street cleaning vehicle in the foreground.

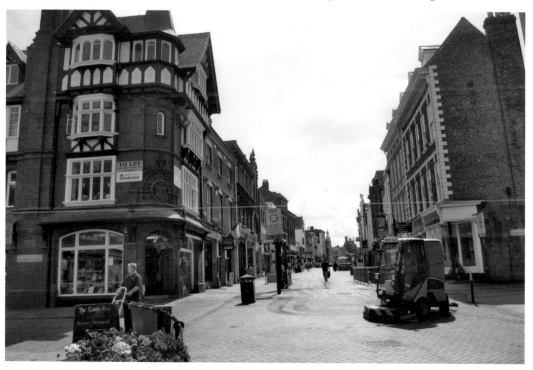

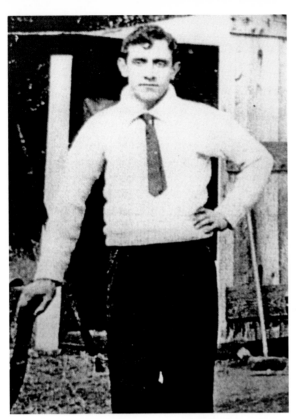

## Tailor of Gloucester's House: No More Twist!

Many readers may recognise the iconic frontage of 9 College Court from Beatrix Potter's popular book *The Tailor of Gloucester*. The story was based on a real man called John Prichard (pictured above). At the time of Beatrix's visit in 1894 Prichard ran a successful business at 23 Westgate Street. A waistcoat mysteriously finished, except for the button holes, was discovered one morning; it later turned out to have been completed, not by mice, but by employees nursing a hangover! Beatrix was inspired by the tale (although it is unlikely she ever knew the truth) and the property she picked for the Tailor's house is now home to the charming Beatrix Potter Museum & Shop.

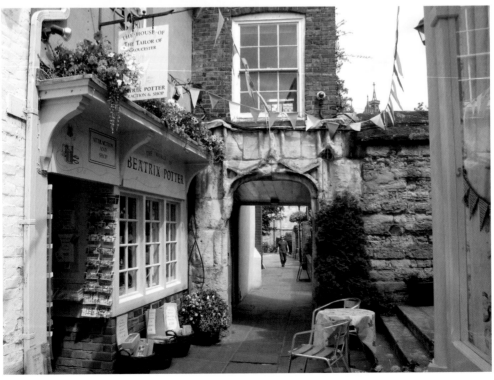

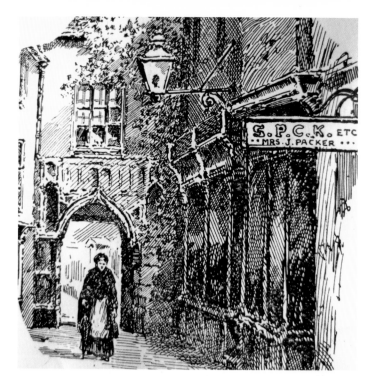

## College Court

Leading from Westgate Street to the Cathedral, College Court is a delightful alley full of bunting, hanging baskets and cafés. There is something very charming and timeless about it and I've always loved strolling through and passing under the arch of St Michael's Gate, which was the original entrance to the lay cemetery of St Peter's Abbey. The window above St Michael's Gate was once the location of Sydney Pitcher, official photographer to the Gloucester Corporation, who was responsible for taking many of the old photographs in this book. Also known as Pilgrim's Gate, the archway can be seen in the sketch above, which was taken from an old advertisement for SPCK (the Society for Promoting Christian Knowledge).

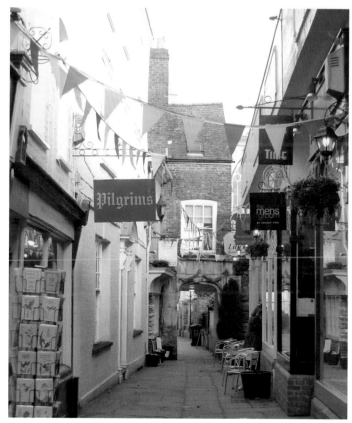

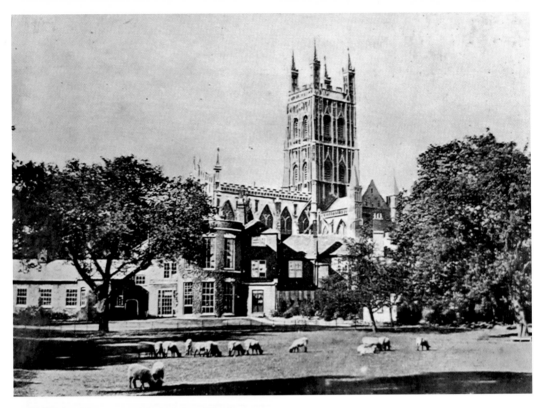

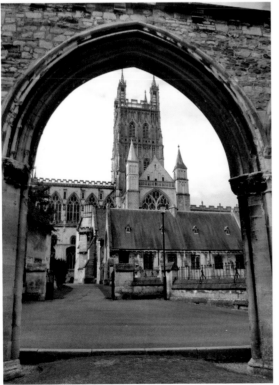

**Gloucester Cathedral from the Paddock**
This idyllic, semi-rural view of sheep
grazing in the paddock is certainly not
something the modern photographer
will encounter – more's the pity.
There has been some kind of religious
monastery around this area since 679
and the 'modern' Cathedral is built on
the site of a Saxon abbey that burned
down. The foundation stone for
St Peter's Abbey (the Cathedral) was
laid in 1089 and consecrated in 1100. A
nine-year-old Henry III was crowned
King there in 1216 and Gloucester
remains the only the place outside
Westminster to hold a coronation since
the Conquest. King Edward II was
buried at St Peter's, which generated
much wealth and brought many
pilgrims to the city.

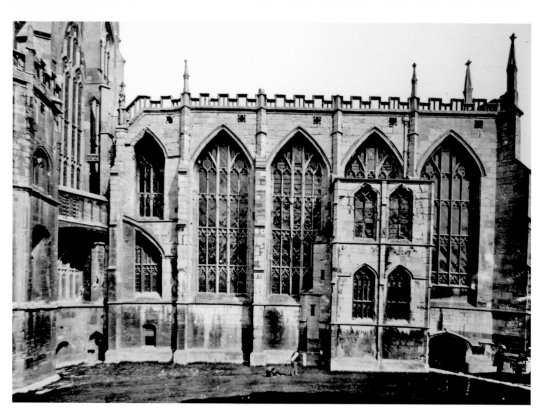

## Gloucester Cathedral

The Cathedral is probably Gloucester's most famous and timeless building and is rated among the seven most beautiful Cathedrals in the world. The photograph above shows a row of stained-glass windows that run down the south side of the Cathedral. You can just make out a gardener with a roller maintaining the grass. Today this area is a popular picnic spot in the shadow of this magnificent building. Having been privileged enough to sing at the Cathedral, I can honestly say the acoustics of this building are truly awe-inspiring.

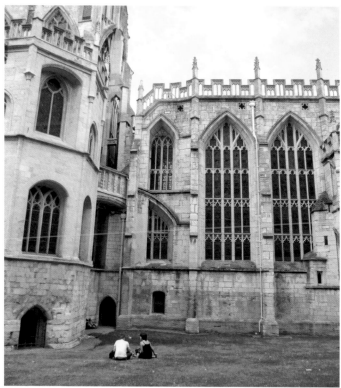

23

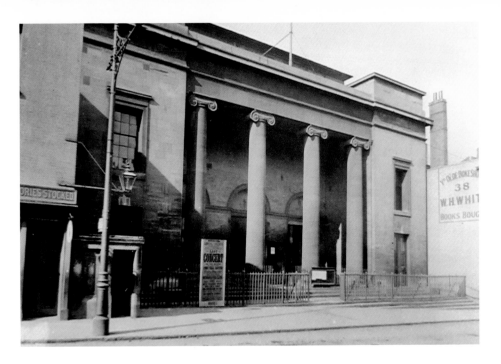

## Shire Hall

Home to Gloucestershire County Council, the imposing pillars of Shire Hall are hard to miss. In the 1960s much of Shire Hall was rebuilt, and large office blocks were installed that extend into Upper Quay Street and Bearland. Shire Hall took over the function of a previous and much older building called the Booth Hall. The Booth Hall not only functioned as the seat of local government but also a meeting place and courtroom. Eventually the Booth Hall became unfit for purpose and work on Shire Hall began in 1815.

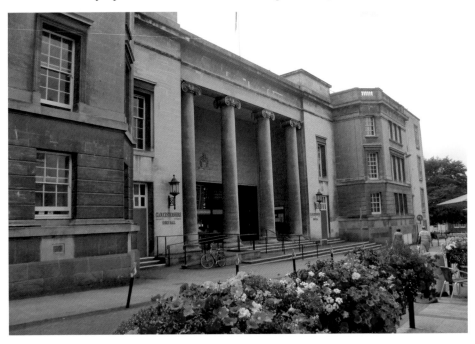

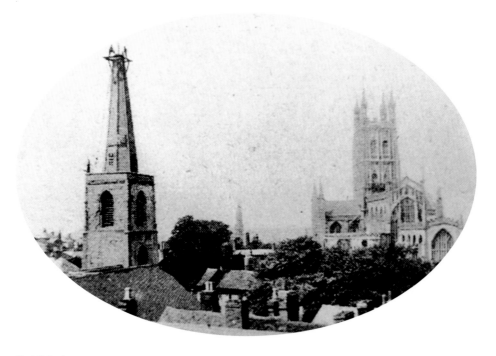

### St Nicholas

Dominating the skyline of Westgate Street, St Nicholas is an impressive sight. Norman sections dating from 1190 can still be seen in parts but most of what remains today was built in the thirteenth and fifteenth centuries. It has long had trouble with its tower. After being damaged in the Civil War, the unstable tower was reduced to about half of its original height in the 1700s. This paper cutting read, 'Removal of Gloucester's crooked tower. The work is being executed by Mr W. Larkins, the "steeple jack" of Alford Road.'

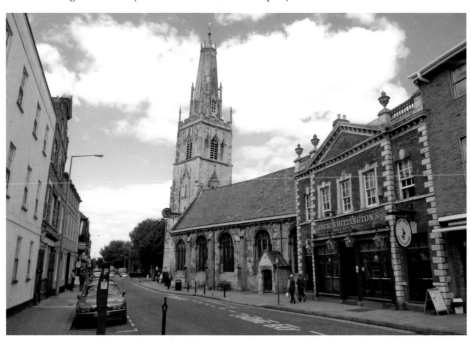

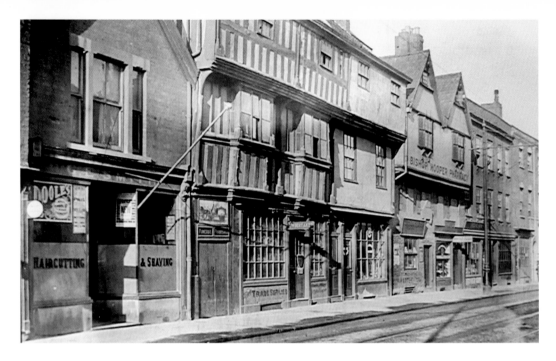

## Bishop Hooper's Lodgings

This building is currently home to the Gloucester Folk Museum and has been used for many purposes over the course of its history, including a pin-making factory and a pharmacy. Locally referred to as Bishop Hooper's Lodgings, it's where Hooper allegedly stayed before his execution in 1555. Records tell of him lodging at the house of 'Robert Ingram opposite the steeple of St Nicholas church', which would certainly fit the description. Charred remains of a stake found at the site of his execution can be viewed in the Folk Museum.

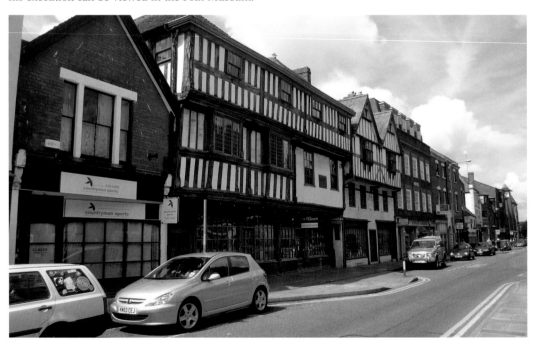

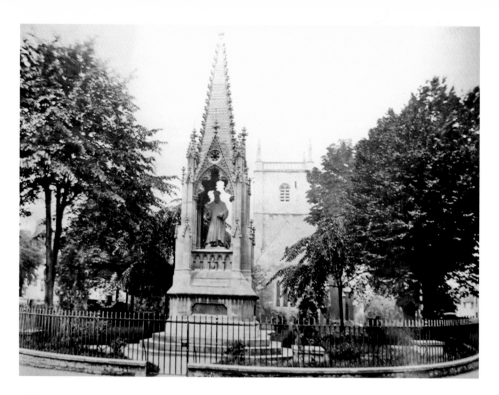

### Bishop Hooper's Monument

Hooper became Bishop of Gloucester in 1551. Having already upset the Church and the King, his views in support of Protestant reform landed him in jail more than once. When King Edward VI died, he perversely decided to support the staunchly Catholic Mary over Lady Jane Grey. His loyalty was rewarded with an accusation of heresy and he was burned at the stake next to St Mary de Lode church, pictured above. This monument was erected to his memory in 1862 on the site of an earlier tribute.

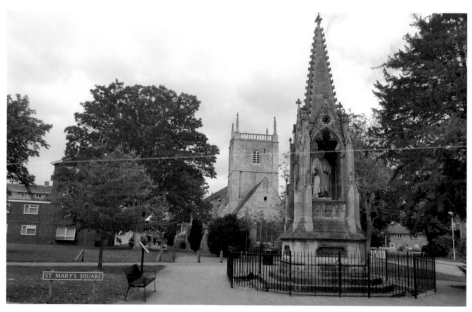

**St Mary's Arch and the Inner Gateway**
This image shows the Inner Gateway leading to College Green from Palace Yard. Cathedral Organist and composer Samuel Sebastian Wesley resided here until his death in 1865. The grander arch of St Mary, pictured below, leads from St Mary's Square to the north-west corner of College Green. The pink half-timbered building to the left dates from the fifteenth century and was built on the site of the old monastic Almonry. Inside, evidence of the window used to distribute alms still exists.

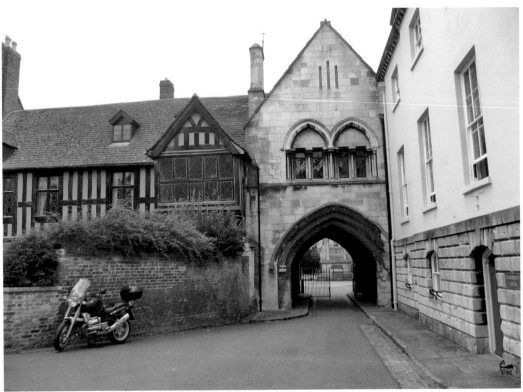

**King Edward's Gate**

This photograph from 1876 shows what remains of the original entrance to the Cathedral from College Street, known as King Edward's Gate. Built in the thirteenth century, the body of King Edward II was received there in 1327 by the Abbot for interment after his murder. This approach to the Cathedral was originally a mere 10ft 9in wide but the street was widened in 1890. The building to the left of the tower is now the Comfy Pew restaurant and was once the servants' Registry Office.

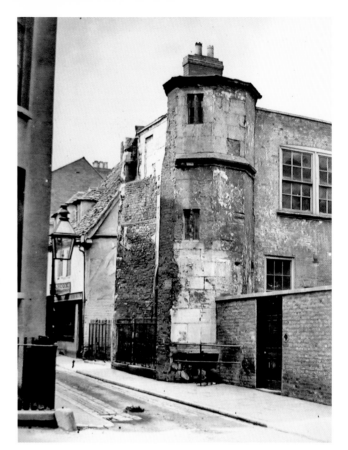

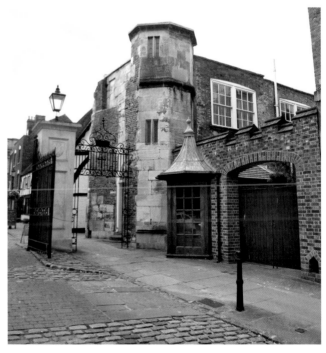

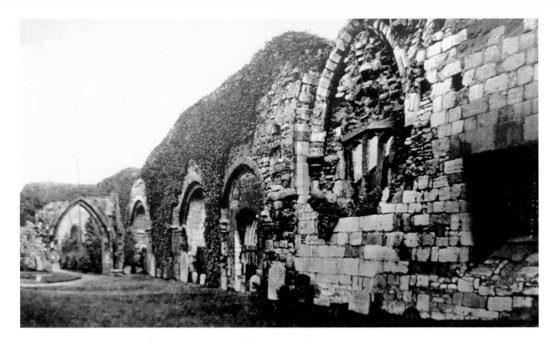

## St Oswald's Priory

The Priory was founded by the daughter of Alfred the Great and takes its name from the martyr St Oswald of Northumbria. The remaining section would have once formed part of the north side of the nave. Following St Oswald's death, his body was dismembered by the pagan king Penda. His arm and head were buried at different locations but the rest of his remains were collected by his niece and eventually brought to Gloucester in AD 909. As with many saintly relics of the day they attracted numerous pilgrims seeking miracle cures.

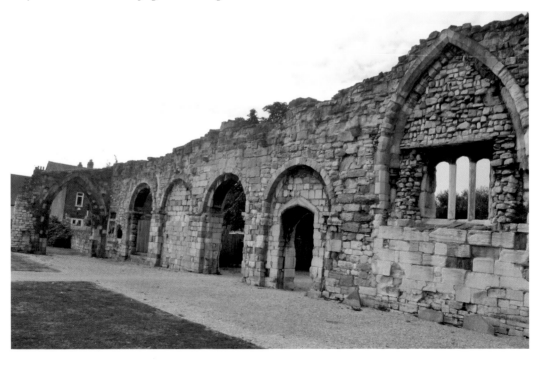

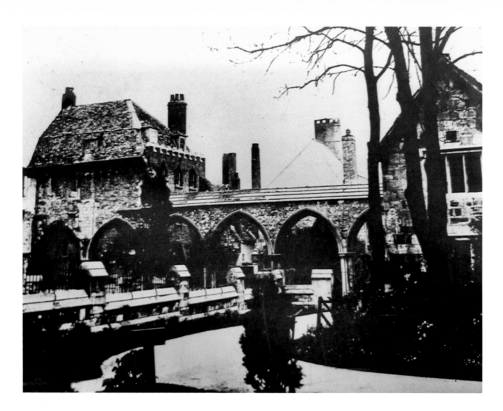

## The Infirmary Arches

These arches are all that remains of the thirteenth-century infirmary. Originally built to care for sick monks, it was later used as accommodation for the families of Cathedral employees. Cathedral organist's son John Stafford Smith famously composed the melody to the 'Star Spangled Banner' and was born here in 1750. The old building to the left of the photograph was demolished to make way for the Bishop's Palace in 1861. The Bishop's Palace was used as a hospital in the First World War and became part of King's School in 1955.

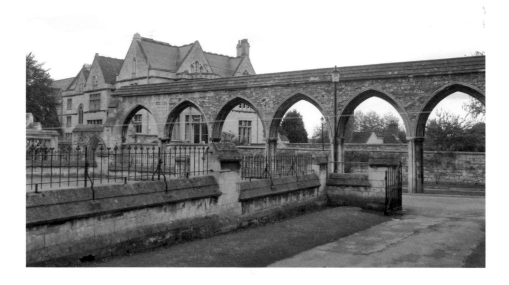

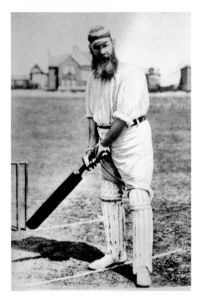
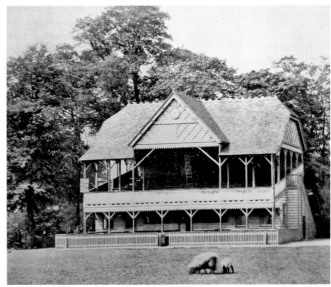

## Archdeacon Meadow

Gloucestershire cricketing legend W. G. Grace, pictured above, was one of the founders of the modern game. The county also has its share of modern cricketers including Gloucester-born Alastair Cook, who earned an MBE in recognition of his prolific run scoring on the 2010/11 Ashes tour. The photograph above shows the old Spa Ground and below Archdeacon Meadow, taken at a match between Gloucestershire and Surrey. Leading Test wicket taker and Sri Lankan spin bowling great Muttiah Muralitharan was playing at this match, having joined the Gloucestershire Gladiators for the Twenty20 season.

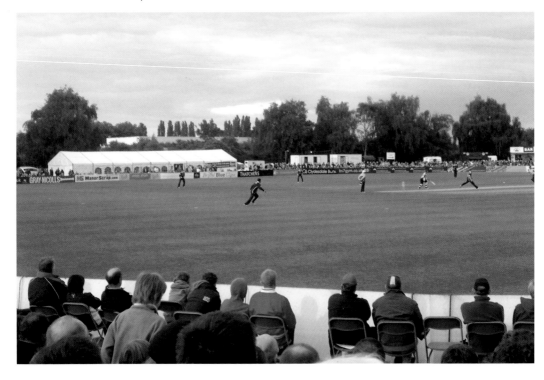

## The River Severn

The River Severn and the city's history are in many ways inseparable, and it could be said that Gloucester owes its existence and success to its geographic positioning. These images depict a rowing boat on the Severn Bore and a view from the river of the Cathedral. The close proximity of the river has also resulted in Gloucester being troubled by floods more than once in living memory. The 'Great Flood' of 1947, following heavy snowfall, and the extensive flooding that swept across the Gloucestershire landscape in 2007.

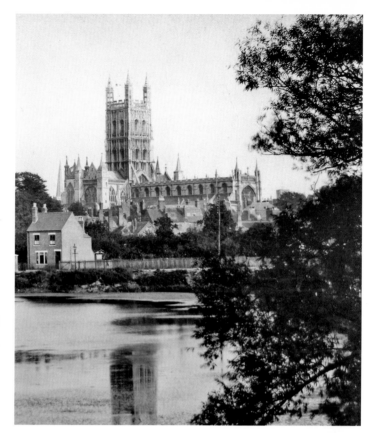

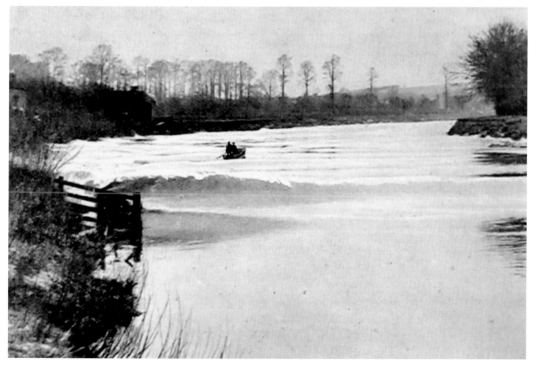

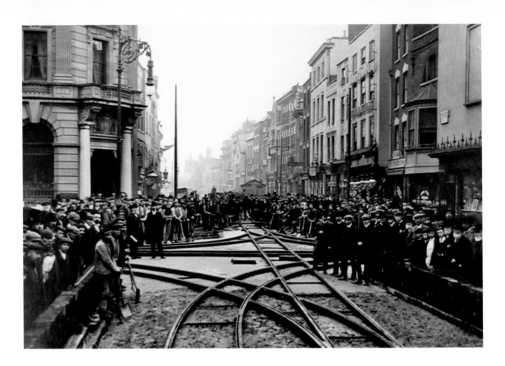

**Laying the Tram Lines**

This photograph shows a view of the Cross towards Westgate Street taken whilst the new tram lines were being laid. This seems to have been quite a local spectacle and has drawn a considerable crowd of onlookers. Today there is no evidence of the tram lines that once ran through the streets and much of central Gloucester has become pedestrianised. The Cross is now host to Gloucester's farmers' market and is a popular haunt for local buskers and performers.

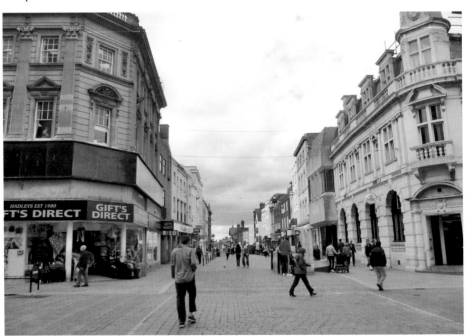

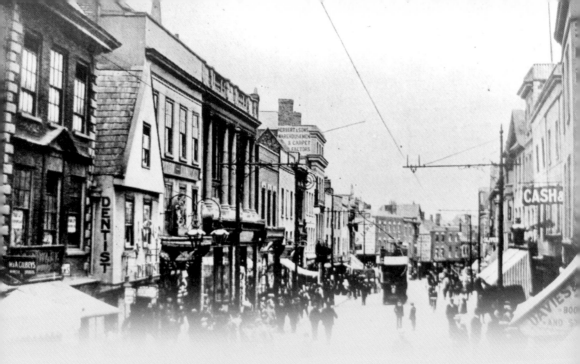

CHAPTER 2

# Northgate Street

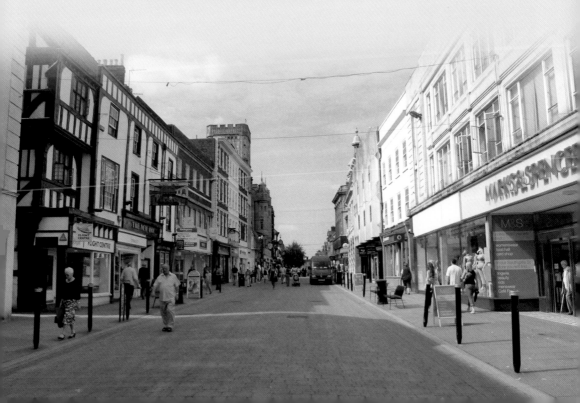

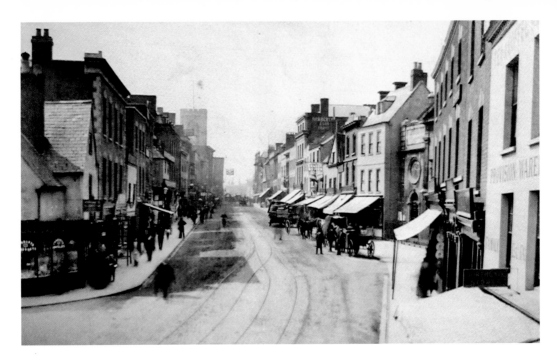

## Lower Northgate

Gloucester's Northgate was the main entrance into the city from London and had become a focal point for trading by the Middle Ages. This view is taken from the lower section of Northgate Street looking towards the Cross. To the left of the photograph you can see the corner of St Aldate Street and to the right the entrance to St John's Lane and the Methodist church. The photographs on the chapter page shows two views taken a little nearer the cross.

## The New Inn

The rather ironically named New Inn was the first of the three 'Great Inns' built by St Peter's Abbey (Gloucester Cathedral) sometime between 1430 and 1450, on the site of an even earlier inn. Originally built to cater for the increasing number of visitors to the city, the New Inn is the oldest pub in Gloucester that is still open today, and as you can see from these photographs, this impressive courtyard remains largely untouched by time. The oak timber-framed building encloses two courtyards and is described as one of the best examples of a medieval galleried inn in Britain. There are many myths about this historic building that live on in local folklore; legends tell of secret tunnels used as escape routes by fleeing monks, performances by a travelling theatre company that was later associated with Shakespeare, and the possibility that the Inn may have played host to Shakespeare himself... Grey's coffee house, attached to the pub, is named after Lady Jane Grey, the nine-day Queen, who allegedly stayed at the New Inn when proclaimed monarch in 1553. Romantic as they sound, the existence of these secret tunnels and other legends is yet to be proven.

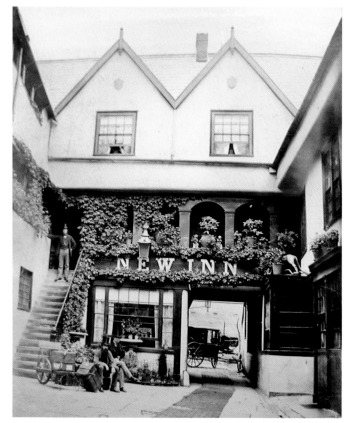

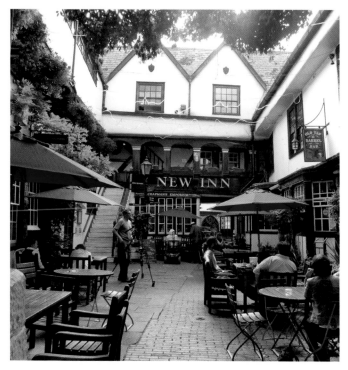

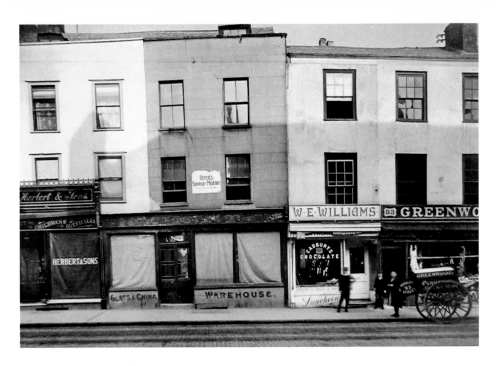

### The Changing Face of the 'High Street'

This selection of images demonstrates not only the changes to this small section of Northgate Street but also examples of trades that have disappeared altogether, such as Badham's the iron monger's. Greenwood's, the butcher's of 93 Northgate Street, would hardly appeal to the squeamish shoppers of today who prefer their meat to come wrapped in plastic, and Minchin's the grocer's of Westgate Street was a world away from the self-service supermarkets we are used to now.

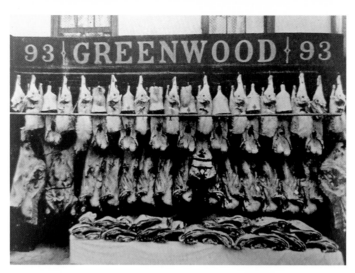

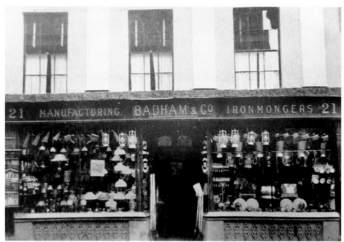

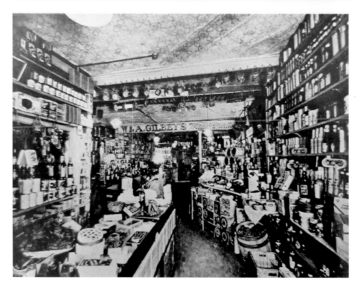

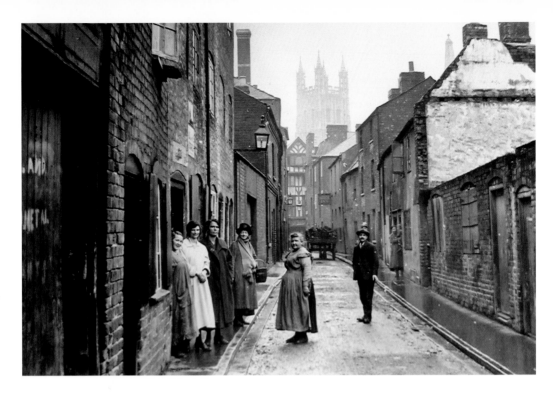

## Oxbody Lane

Oxbody Lane, or Mitre Street as it was later known, was redeveloped beyond recognition in the 1930s. It was one of the poorest areas of Gloucester and was targeted by the late 1920s slum clearances. The area, now known as the Oxbode, is located just off of Kings Square and is best known for the large Debenhams department store. Originally the street was much narrower and it is believed the name dates back to the thirteenth century.

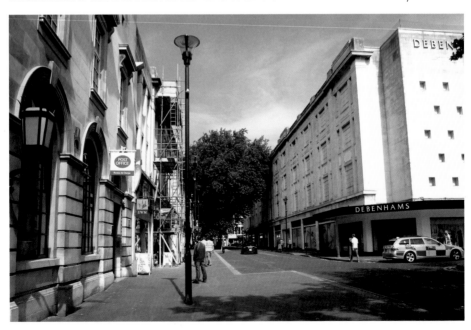

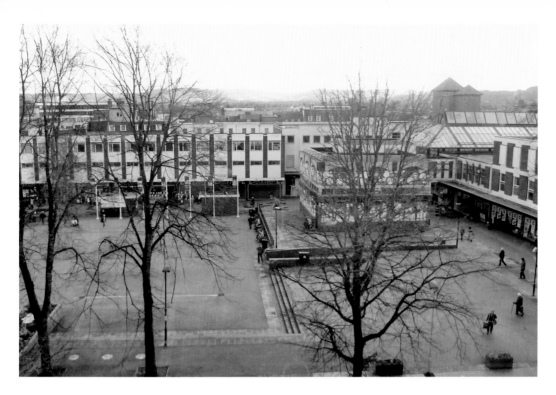

### Kings Square

This aerial view of Kings Square would have looked very different even a few decades ago. I remember a previous incarnation of this area with fountains and stepping stones. My Dad used to buy me gingerbread from the nearby baker's and take me to watch the fountains as a child. The square was used as a car park in the 1960s and has recently been levelled so it can hold markets and an ice rink at Christmas. Below, another contemporary view across the Square.

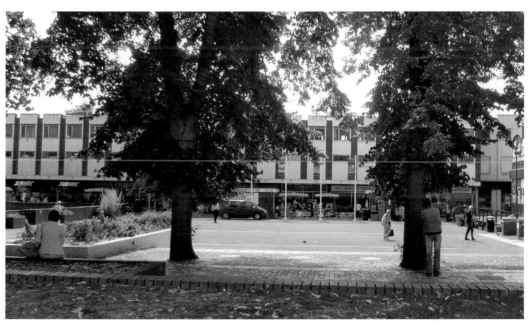

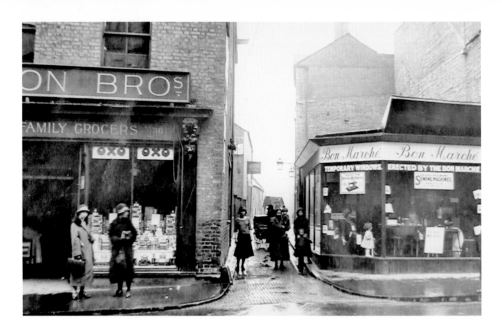

## Bon Marché

This image was taken looking from the other side of Oxbody Lane next to part of the old Bon Marché store. The Bon Marché was started by John Rowe Pope in 1889 and the image below shows a typical window display. The popular drapery business started out in Northgate Street and expanded over the years. The original store was demolished in 1931 and a new building was put in its place as part of the Oxbode redevelopment. The store changed its name to Debenhams in the 1970s.

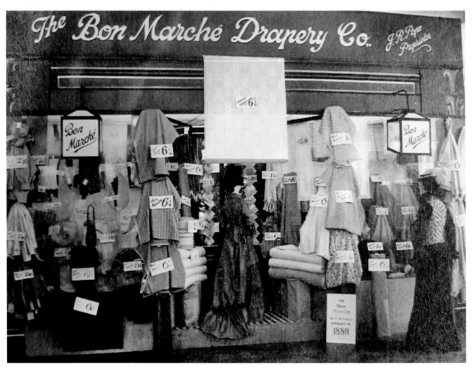

### St Aldate Street

This photograph of St Aldate Street is taken from a postcard sent in 1905. It shows a view looking towards Northgate Street. The building to the left of the original photograph is the white building located just behind Debenhams in the modern image. The colourful awnings and horse-drawn carriages that once filled this street have been replaced by cars and modern shop-fronts. To the right of the image below you can see The Regal. Previously a Regal/ABC cinema, it has since been converted into a Wetherspoons pub.

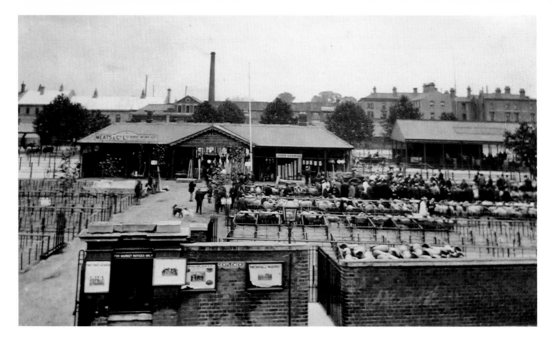

## Market Parade

Many people pass through Gloucester bus station or park their car at the Market Parade multi-storey car park without realising where the area got its name from. Originally home to Whitefriars Priory, which was destroyed in the Siege of Gloucester in 1643, the old cattle market shown above was moved to the site in the early 1820s. Public auctions began in the 1860s and in the early 1900s a fruit market was also established on the site. The market gradually expanded over the years until it was moved to a new site at St Oswald's Road in the 1960s. The story of the 'cattle market' ended in 2005 when the St Oswald's site finally closed.

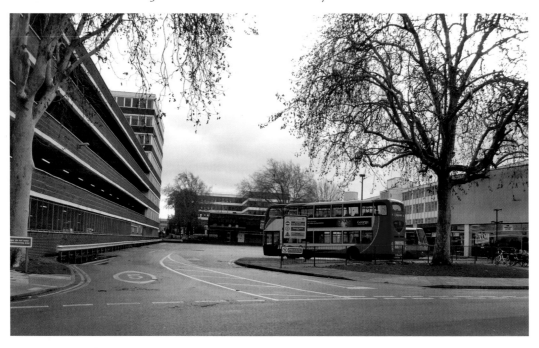

## Old Raven Tavern

Built in around 1520, this charming black-and-white building is popularly referred to as the Old Raven Tavern. It was saved from demolition by the people of Gloucester in 1939 due to its alleged connection with the Hoare family, who sailed to America on the *Mayflower*. It was later discovered that the building probably had no connection with the family as the 'real' Raven Tavern was most likely located elsewhere. To the far right of the above picture you can see the edge of the building, which is now a Sainsbury's store. The old sign that detailed the inaccurate history of the 'Tavern' could be seen to the right of the window but has since been taken down.

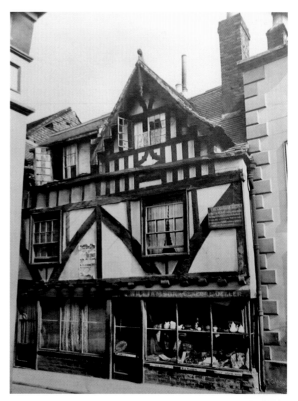

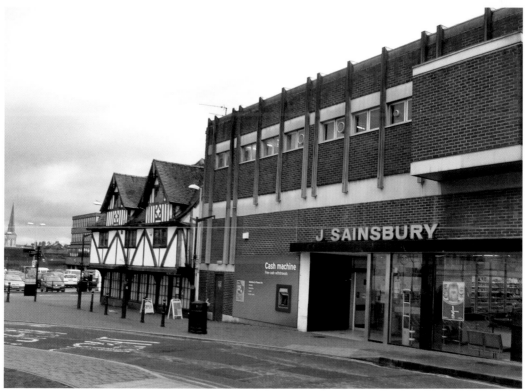

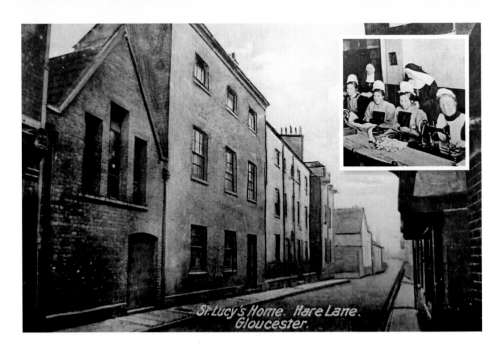

St. Lucy's Home. Hare Lane. Gloucester.

### St Lucy's Home of Charity

Caring for the sick and needy, the Church of England sisterhood that ran St Lucy's provided an orphanage and industrial home for local girls and training to enable them to get jobs in service. A sewing class overseen by some of the nuns, using old-style hand-operated machines, is pictured above. The building was demolished, but the lawns at the rear of the property, now known as St Lucy's Gardens, are a pleasant spot on the corner of Hare Lane and Pitt Street.

**Park Street Mission Room**

The Park Street Mission Room originally consisted of two cottages that were purchased in 1678 and converted to form a Quaker meeting house. George Fox and William Penn are both said to have preached there. The Society of Friends worshipped at Park Street exclusively until the meeting house in Greyfriars was opened in 1834. The old cottages were replaced by a larger building in 1903, which is still in use today.

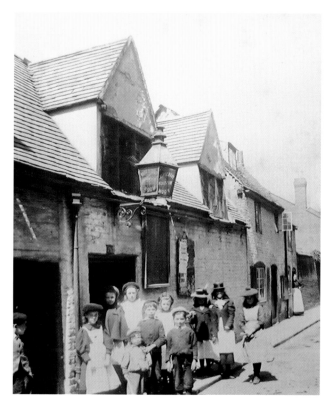

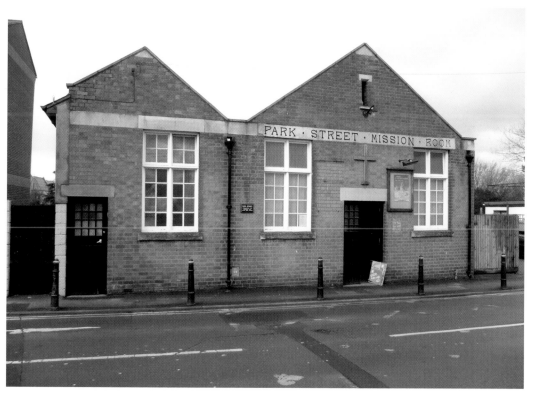

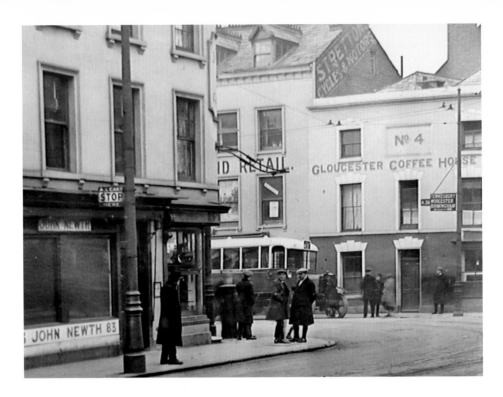

### Worcester Street

Hare Lane used to be the main road into the north side of Gloucester until Worcester Street was built in the 1830s. This photograph was taken on the corner of Worcester Street where it meets Northgate Street and the London Road. The buildings next to the bus stop have been demolished and a Cash Converters store now occupies the site. The shop at No. 83 Northgate Street, formerly John Newth, remains largely unchanged and is now an Age UK charity shop.

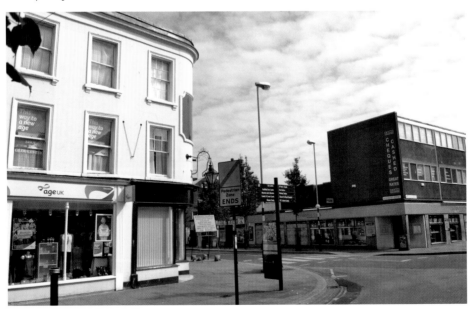

## London Road

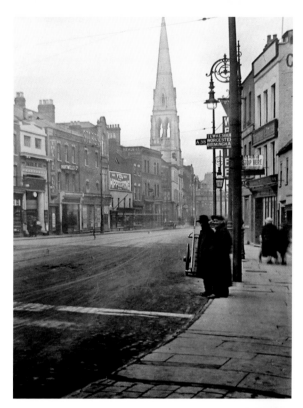

This view shows the very end of Northgate Street where it meets the London Road, which predictably is the main route into the city from London. The spire of St Peter's church marks the transition. Mention should also be made of Alvin Street, which links London Road and Worcester Street. Once the location of Kingsholm School, it is now occupied by Gloucestershire Archives. It borders the area popularly referred to as Clapham, which was built in the 1820s to accommodate the influx of workers brought to Gloucester by the Industrial Revolution.

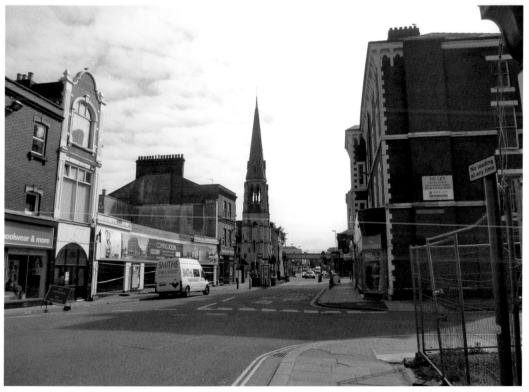

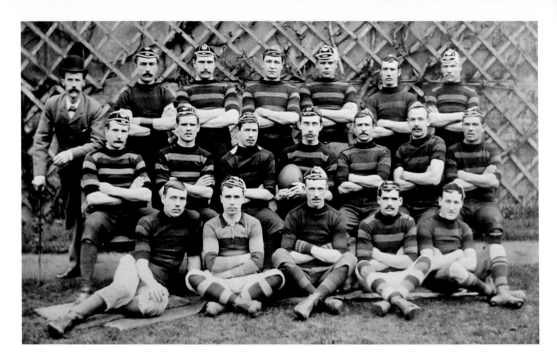

'C'mon Glaws'

Gloucester RFC was founded in 1873 by Francis Hartley. Originally the team played at the Spa Ground before moving to Kingsholm in 1891. The Cherry & Whites got their name from a strip they borrowed from Painswick RFC, which consisted of white work clothes with a sash of red curtain, courtesy of the vicar's wife! The shot above shows the first fifteen of 1885 and below a sunset over the grounds at Kingsholm. A popular standing area called the 'Shed' can be seen to the right of the photograph.

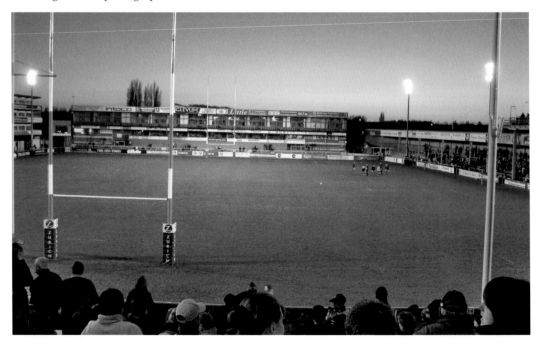

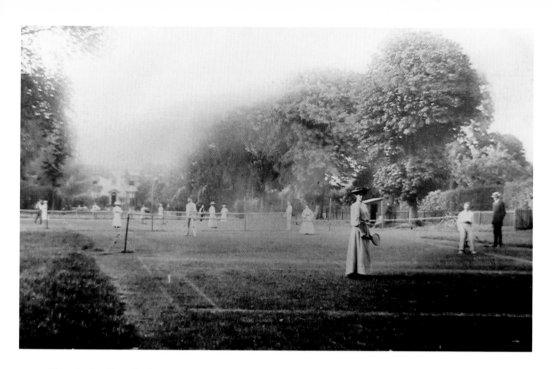

### Kingsholm Tennis Courts

The image above shows a view of Kingsholm Tennis Club. I believe it depicts the lawn tennis courts, which still exist, in Kingsholm Square. The lady in the foreground would certainly look out of place on a court today in her elegant dress and wide-brimmed hat. Possibly taken at a tournament, this busy sporting scene is a far cry from the modern game, now devoid of wooden rackets and where energy drinks have replaced afternoon tea!

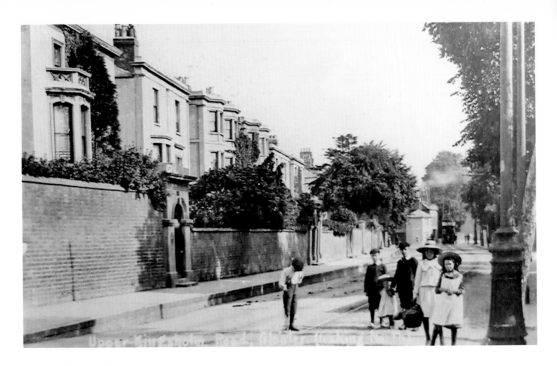

## Kingsholm Road

This view of Kingsholm Road has altered considerably since the original image was taken in 1915. Far from being somewhere children can stroll down the middle of the road, the area has become dominated by cars and the steady flow of traffic into the north side of Gloucester. Despite the very modern Hyundai garage to the right, some original features do still remain. The gateway to the left and the toll house in the distance are clearly visible in both images.

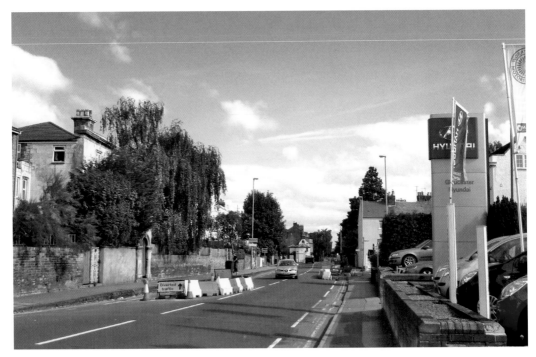

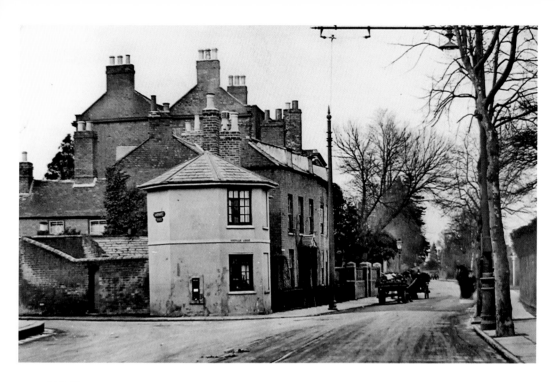

## Toll House

This quirky building on the corner of Kingsholm Road once functioned as a toll house. It is presumed that the Kingsholm Gate Toll House was built for the Cheltenham and Gloucester Turnpike trust in the early 1820s. Built in the traditional octagonal shape, 'Old Turnpike House' is now a Grade II listed domestic property and a distinctive feature of this approach into Gloucester.

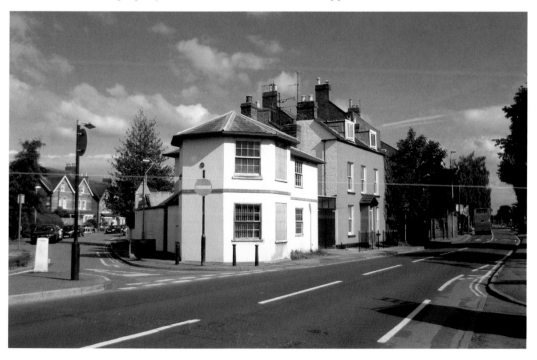

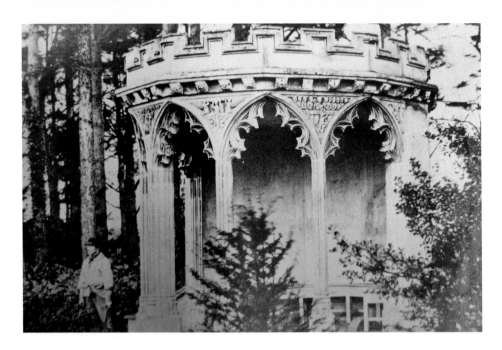

## King's Board

The King's Board was originally part of a much larger rectangular building dating from the fourteenth century and located in Westgate Street. It was situated within the medieval market but its original use is unclear. By the sixteenth century it was used for the sale of butter and cheese, which is why it is also known as the Butter Market. In the 1700s the building was dismantled but some sections were used to create a summerhouse, which moved several times before finally being located in its present site in Hillfield Gardens.

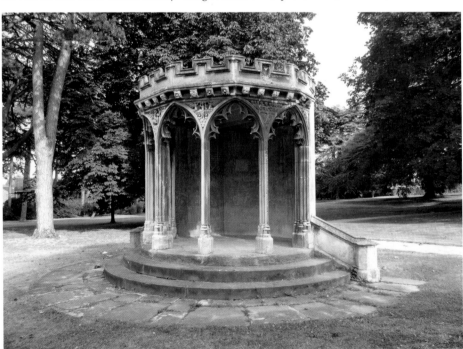

## Scriven's Conduit

The wonderfully named Scriven's Conduit was given to the city by Alderman John Scriven to provide the local area with clean water, piped from nearby Robinswood Hill. It was originally located in Southgate Street, near Longsmith Street, and has been situated in Hillfield Gardens on the London Road since 1937. This photograph below shows a passer-by admiring this piece of elaborate seventeenth-century carving.

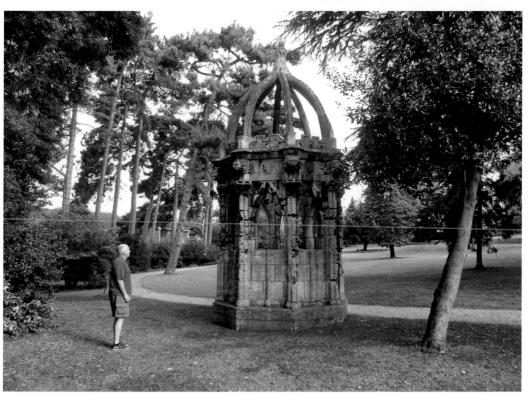

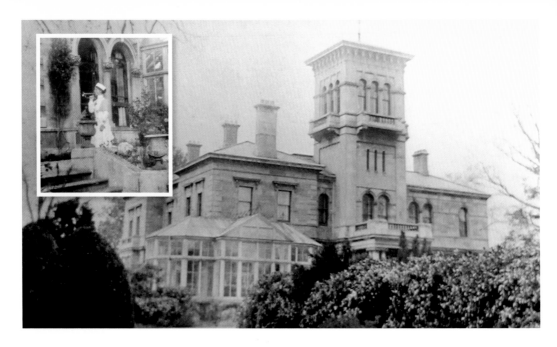

## Hillfield House

Hillfield House is located on the London Road and is presently home to Trading Standards. The house was used as a Red Cross Hospital in the First World War until the casualties from the Somme exceeded its capacity and the operation was moved to the Bishop's Palace. The image of a Red Cross nurse with a bugle was taken on the steps to Hillfield House during this period. You will notice that the glass conservatory has been removed from the building but externally it has escaped any radical changes.

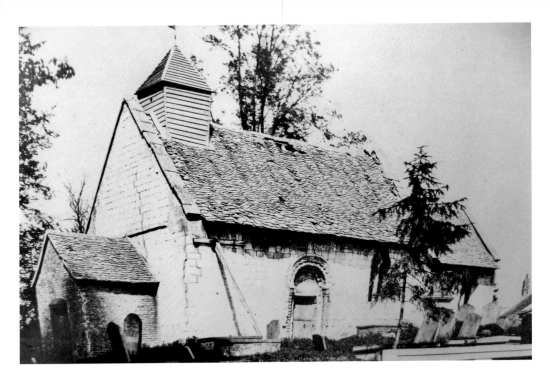

## St Mary's Hospital

Set some way out of the city centre in Hillfield Gardens, the chapel of St Mary Magdalen originally served Gloucester lepers' hospital and later the St Mary Magdalen almshouses. Following the rerouting of the London Road in 1821 the chapel became cut off from the hospital and fell into disuse. The nave and hospital buildings were demolished in 1861 but the chancel was saved and remodelled to include the old south doorway. Some interesting historic 'graffiti' can be seen carved onto the exterior.

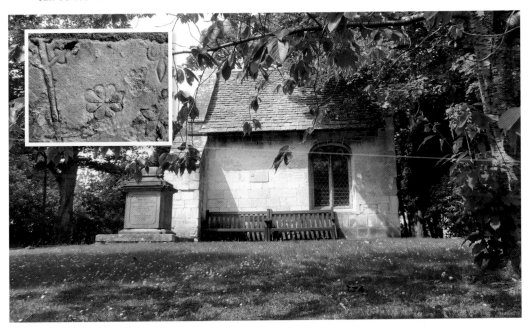

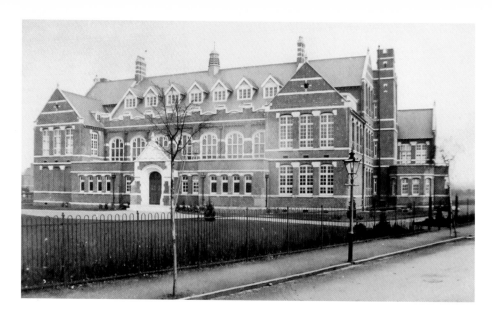

## Denmark Road

Once known as Gallows Road, Denmark Road is the present location of the High School for Girls, which was founded in 1883. I spent my formative years in the various corridors and classrooms of this building. The school now has Language College status and has added many modern facilities; however, I was always fondest of the old stone staircases and stained glass windows. The may tree crest and striped shirts are still worn by pupils and the whole school walks to the Cathedral for an annual Founder's Day service.

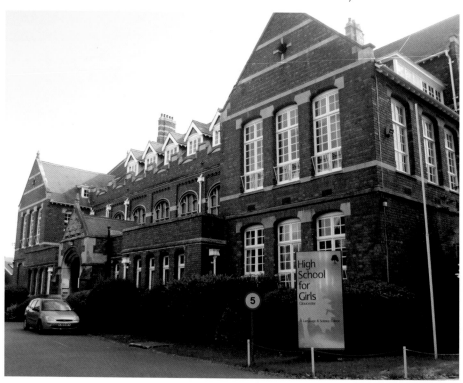

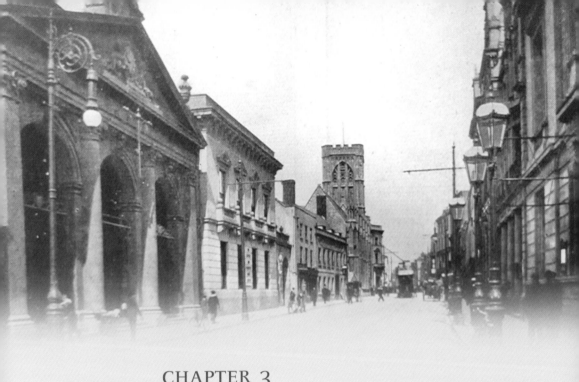

CHAPTER 3

# Eastgate Street

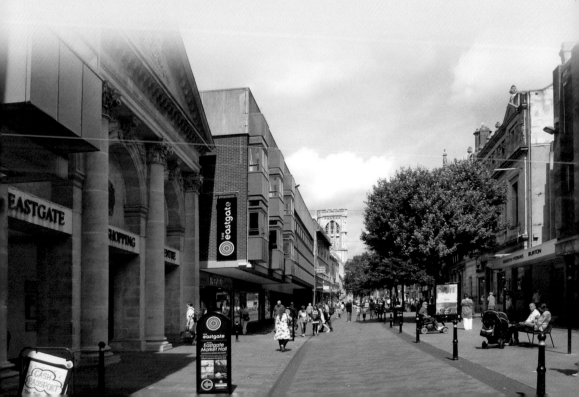

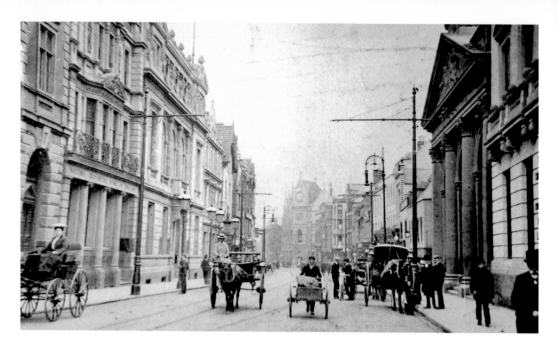

### Eastgate Street Towards Brunswick Road

The photograph above shows a view looking towards the junction with Brunswick Road. Remains of Gloucester's Roman walls can still be viewed there. The old co-operative building, now Argos, can be distinguished by the clock face in the distance, but much of this view has been obscured by the addition of Bridge Studios, home to Gloucester's local radio station. The photograph overleaf shows a view looking the opposite way, by the market portico. Originally positioned nearer the Cross, it was moved in 1973 following the completion of the shopping precinct.

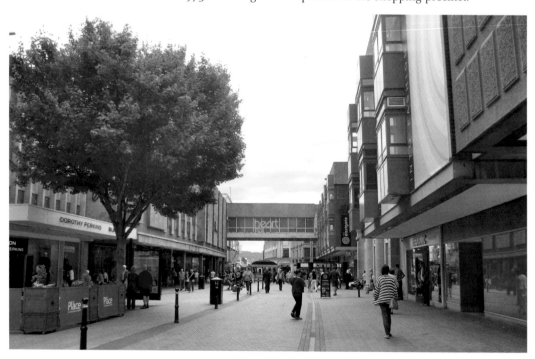

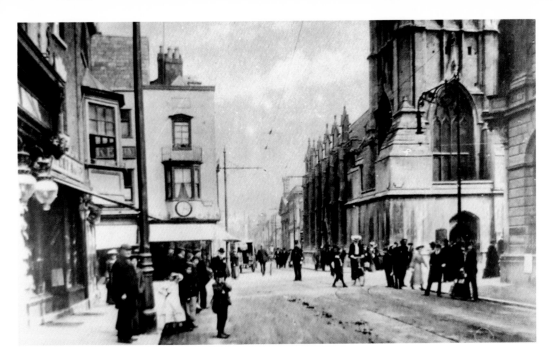

### St Michael's Tower

The photograph above shows a busy street scene outside St Michael the Archangel church. The main part of the church extended into Eastgate Street, and was demolished in 1956, leaving only the Norman bell tower. Modern shops now occupy the site of the old church and St Michael's Tower is presently the headquarters of the Gloucester Civic Trust, who rescued and restored it in 2004.

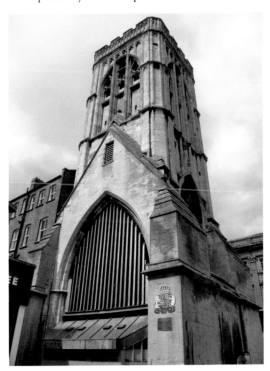

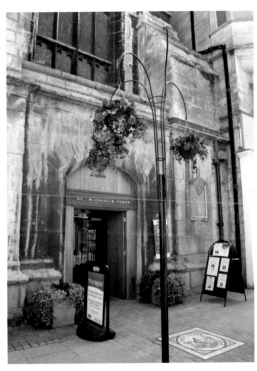

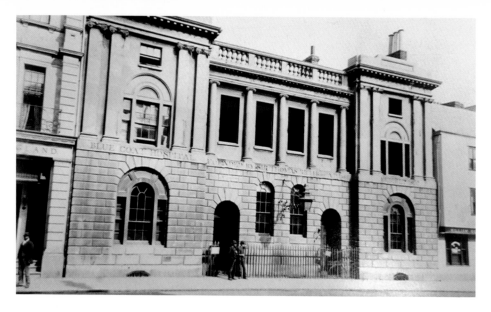

### 23 Eastgate Street, Blue Coats Hospital

The Blue Coats Hospital was founded in 1668 with a bequest from Sir Thomas Rich. The building shown above was demolished in 1890 when the school moved and it was replaced with the Guildhall. C&G now occupies the ground floor and the Guildhall Arts Centre on the first floor has become a popular local venue. In the late 1880s, when this photograph was taken, the whole area was redeveloped. The building just visible to the right of the photograph was formerly the Saracens' Head Inn. Dating from about 1680, the inn was completely rebuilt in 1890 and finally demolished in the 1960s to make way for the store, which is currently Dorothy Perkins.

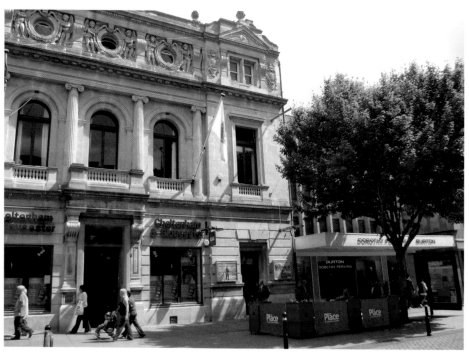

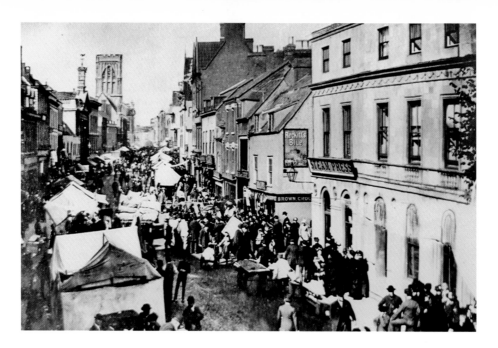

## Barton Fair

In 1465 the fair was held in Barton Street. The photograph above, taken in 1882, shows the Barton Fair extending into Eastgate Street and below the current Friday Market stalls. Gloucester is famed for its Double Gloucester cheese and Old Spot pigs. Following the Civil War the city boundaries were reduced, meaning Barton Street was not under the control of the Mayor of Gloucester. A tradition that has recently been revived was to elect a 'mock mayor' to poke fun at Gloucester.

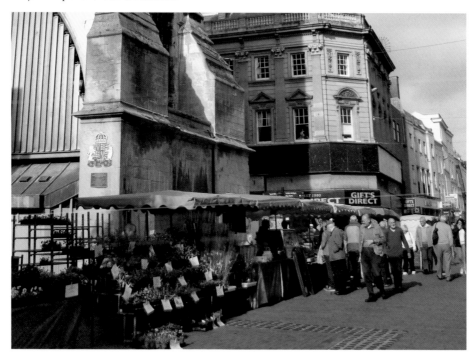

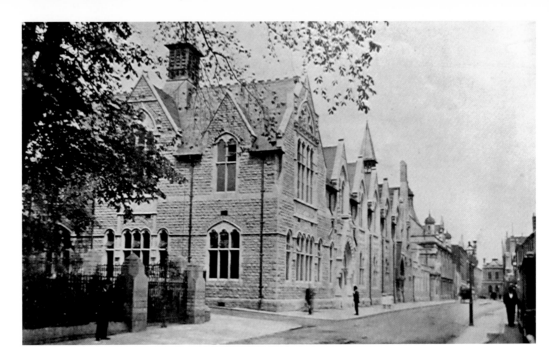

### Gloucester Library

Gloucester Library opened in 1900 and, except for the removal of railings to the left of the photograph, this view has changed very little since the original was taken. I walked past this building every day when I was a student at the media college opposite. Little did I realise I would come to work in a library myself and witness firsthand the changing role of libraries within communities. Gloucester has one of the last surviving reference departments in the county, but has also evolved with the demands of the age from a purely book-based environment to incorporate new ways of accessing information, such as the internet.

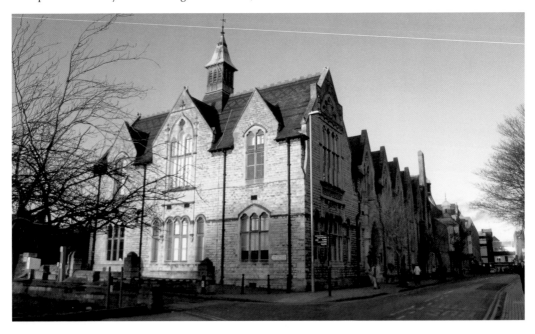

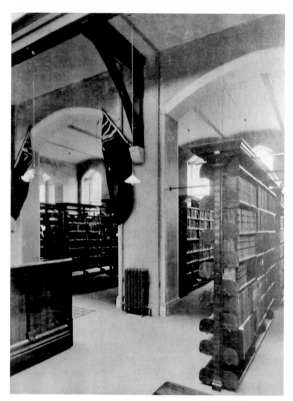

## Gloucester Library Shelves

Whilst aesthetically the library may have altered very little externally, it's not just the outside of a building that is subject to change. The bright modern interior of Gloucester Library is in stark contrast to the neat rows of dark, wooden bookshelves shown in the picture above. As my natural habitat is amid the dusty shelves of second-hand bookshops, I have to admit a pang of nostalgia for the loss of the 'traditional' interior! On entering the library now, readers will find themselves not only amid books but also computers, DVDs and self-service machines: a concept unthinkable when this library was first built.

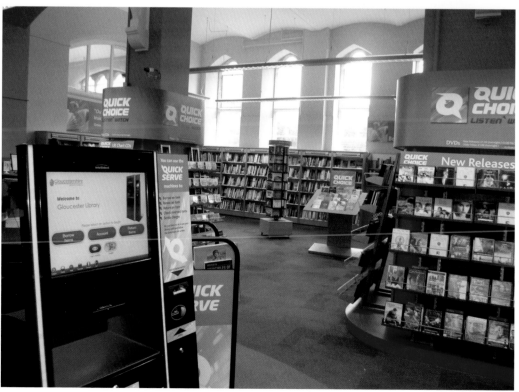

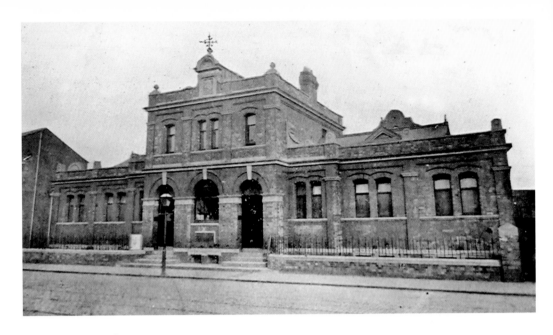

## Barton Street Baths

The Victorian public baths, pictured above, were located a stone's throw from the modern GL1 leisure centre. The original red-brick entrance to Barton Street Baths can still be viewed nearby. In the 1960s the public baths were replaced with a new swimming pool complex, which was in turn pulled down and expanded considerably to form the current modern sports and swimming facility pictured below.

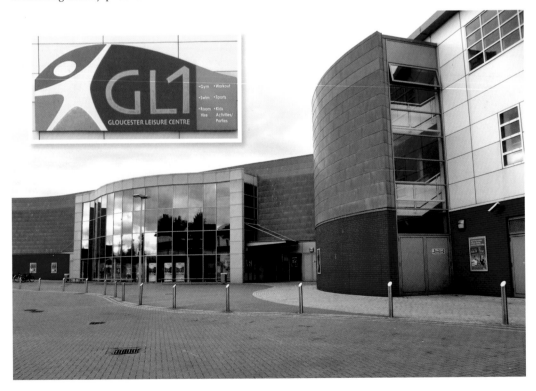

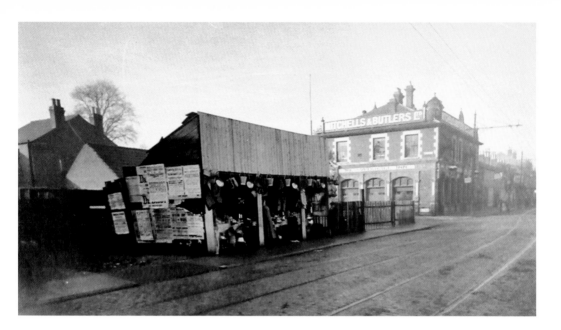

### Vauxhall Inn

The Vauxhall Inn stands on the corner of Vauxhall Road in Lower Barton Street. It was built in 1876 by Mitchells & Butlers in the Arts and Crafts style. Much of the exterior, including the traditional glazed tiles, has been preserved, although its function has changed. The pub closed in 2008 and was transformed into Barton Street's first supermarket, catering for this vibrant, multicultural community. The area around the inn has been developed over the years; however, at one time there was an attached pleasure garden and private zoo!

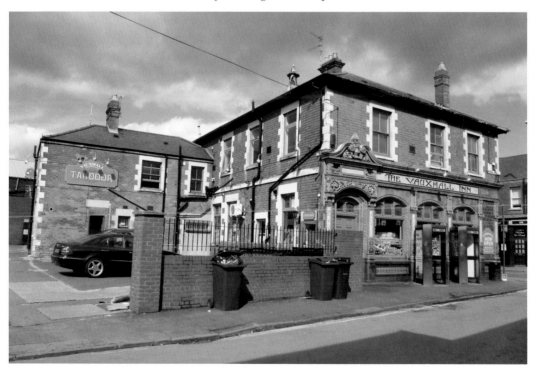

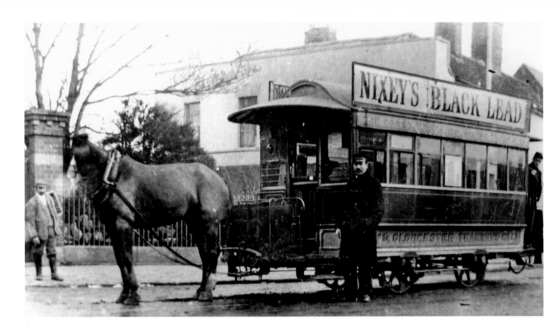

## Tram in India Road

The photograph above was taken at the terminus in India Road. Whilst the mode of transport may have changed radically since the days of this horse-drawn tram, some things have not. The posters on the side of the double-decker bus below may seem like a very modern idea; however, products have been advertised on public transport for well over 100 years.

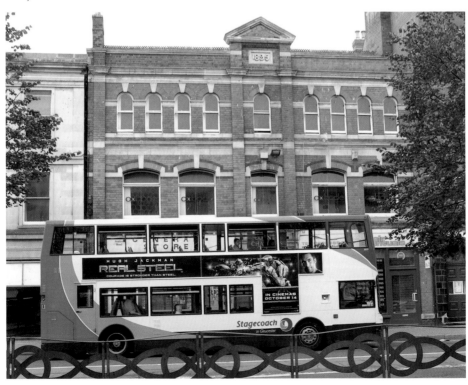

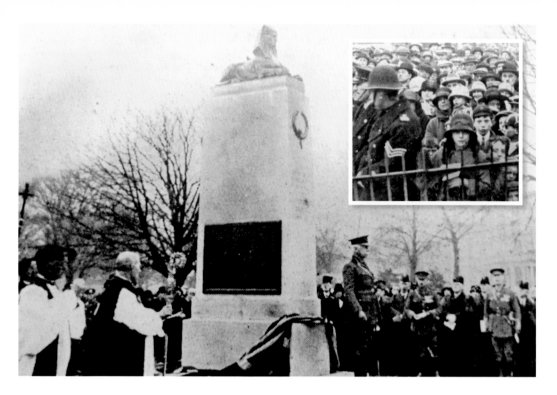

## War Memorial

The Cenotaph was unveiled on 28 March 1928 and originally erected as a memorial to the 5th Battalion. A sphinx, emblem of the 5th Battalion, sits on top of an obelisk and the names of the fallen from both World Wars are listed on each wall behind. This emblem was awarded during the Napoleonic wars in Egypt when they also earned the right to wear a badge on the back and front of their headwear. This is also where Back Badge Square, home to the excellent Soldiers of Gloucestershire Museum, gets its name.

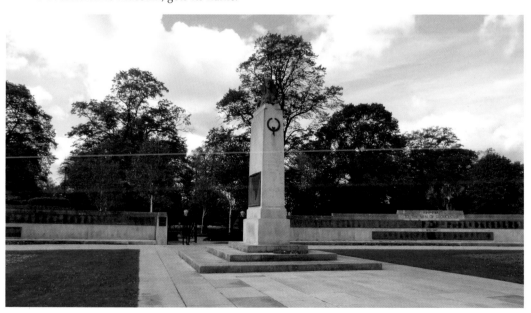

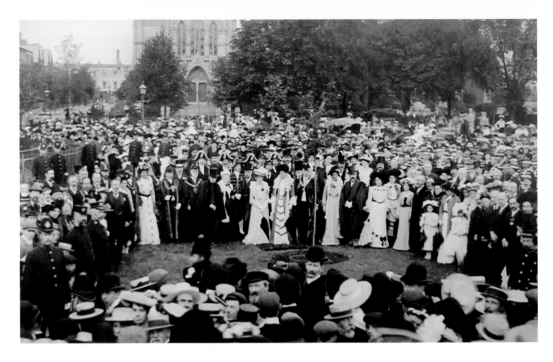

**Coronation Oak**

This photograph was taken in 1902 across Gloucester Park facing towards the United Reform church. The mayor, bishop and other officials are shown planting an oak tree to commemorate the coronation of King Edward VII in front of a large crowd of locals. Today the oak tree is thriving and is pictured behind the fountain, which was originally located in the Eastgate Market.

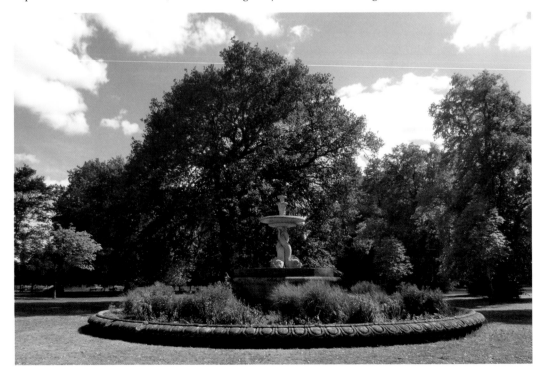

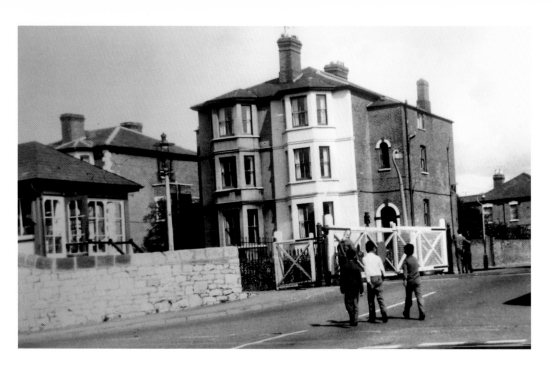

## California Crossing

The photograph above shows a view of the level crossing that used to be on the corner of Midland Road. California Crossing signal box, shown in its original location to the left of the photograph, can now be found on the North Gloucestershire narrow-gauge railway at Toddington. Cars are the only form of transport that passes here now, and the house that once overlooked the railway line is currently a guest house.

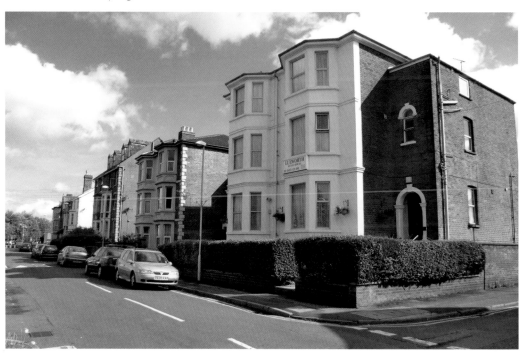

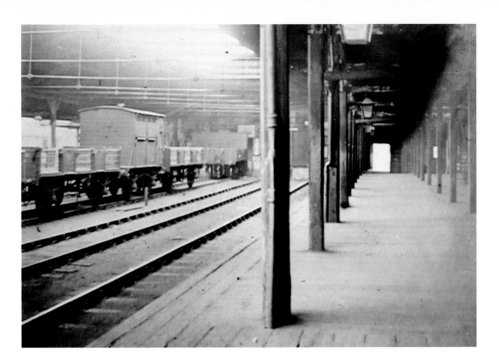

### Midland Railway Station

In 1896, a through station simply called 'Gloucester' was constructed on the Tuffley loop of the Midland line. The station had three platforms and the area was previously engine sheds. The station was renamed 'Gloucester Eastgate' in the 1950s to differentiate from 'Gloucester Central' the rival Great Western railway station. 'Eastgate Station' finally closed in 1975 along with the whole Tuffley loop, and several level crossings were removed. It was demolished in 1977 and is now occupied by an ASDA supermarket.

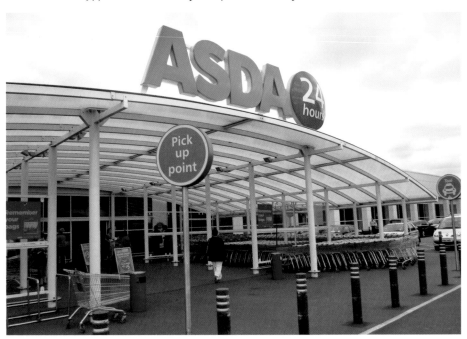

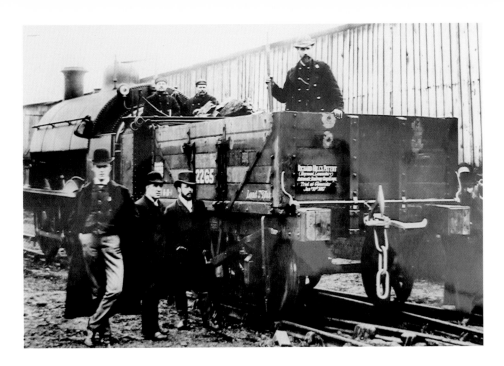

### Gloucester by Rail

With assistance from the Restoration & Archive Trust I have managed to discover that the above photograph was taken during a successful trial of Mr Richard Hill's automatic railway couplings at Gloucester. The couplings, forged by Gloucester Wagon Company, were trialled in January 1887 using old coal wagons; the idea was later developed by another inventor. The railway reached Gloucester in the 1840s, bringing with it new materials, trade and wider markets. Two rival companies – Midland (from Birmingham) and GWR (from Swindon) – met in Gloucester, sparking competition.

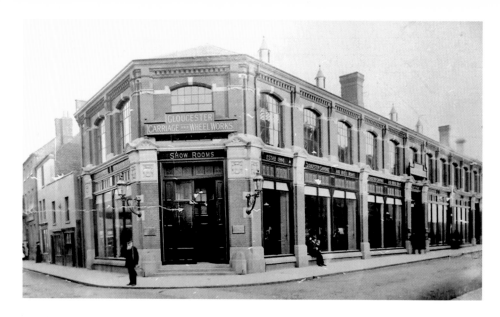

## Carriage and Wheel Works

Gloucester Wagon Co. became the largest employer in the city and at the end of the nineteenth century had a workforce of over 1,100. They took over the Carriage and Wheel Works in Ladybellegate Street from Mousell Brothers and built their own showroom, pictured above, on the corner of London Road and George Street. Below, a scene of military ambulances built by the Gloucester Wagon Co. going off to the South African War.

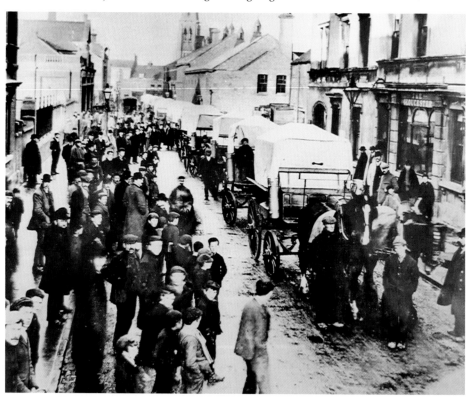

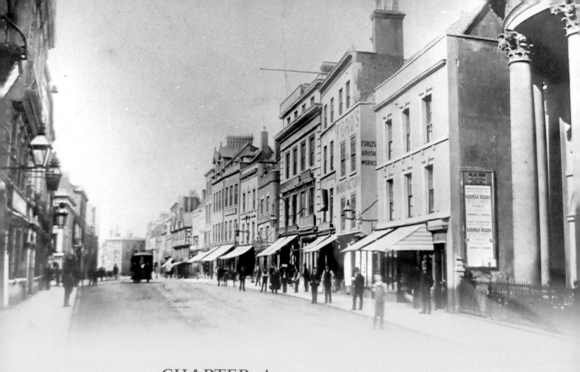

# CHAPTER 4

# Southgate Street

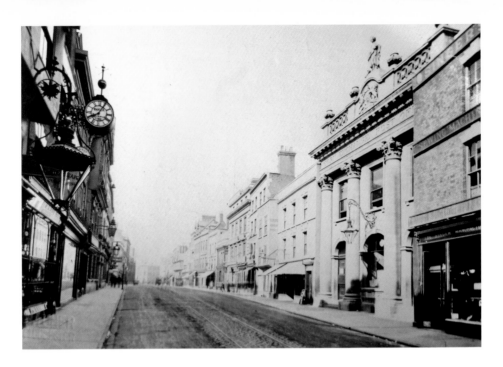

### Southgate Street

Southgate Street, or 'The Great South Gate' as it was once known, was the main route between Gloucester and Bristol and a prominent trading area. The image overleaf was taken from under the Baker Clock and shows a view from the Cross looking south towards Robert Raikes' House; the Corn Exchange is on the right. The image above shows the same view some years later with the post office building where the old Corn Exchange once stood. Today the post office is located in the Oxbode.

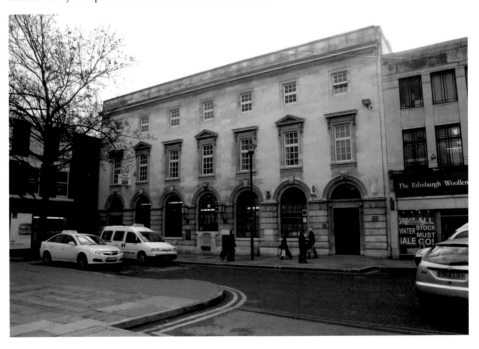

**The Old Tolsey**

The Old Tolsey (or town hall) was built in 1751 and stood on the corner of Westgate and Southgate Street by the Cross. This photograph was taken just prior to its demolition in 1892 after the Guild Hall was built. At one point the post office used the basement of the Tolsey before being relocated to the Corn Exchange. As with many buildings in the city, you need to look up to appreciate the architecture of the present building, which is occupied by 'Gifts Direct'.

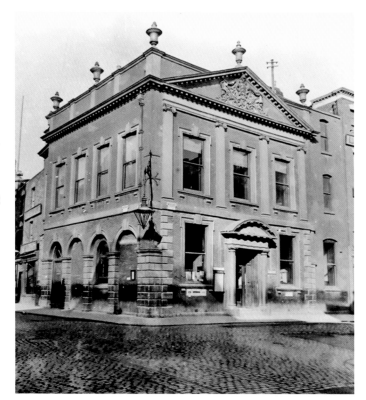

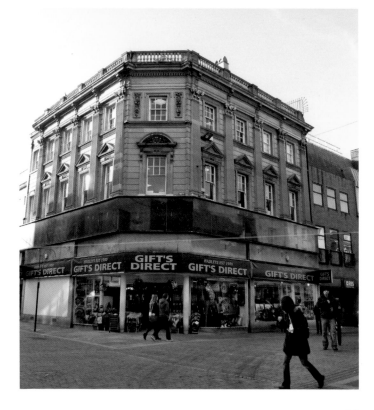

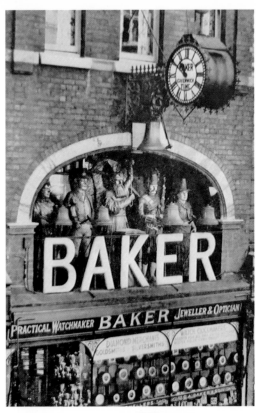

### Baker Clock

The ornate wrought-iron clock above Baker's has been a prominent and memorable feature of Southgate Street for many decades. The traditional painted shop-front has also remained unaltered, still advertising the 'Practical Watchmaker, Jeweller and Optician'. Father Time and the four national figures were added in 1904 and continue to strike the hour to this day. I can remember my parents taking me to see the clock to amuse me on Christmas shopping trips as a child. The shop is still a jeweller's today, but as you can see from the photograph, the large letters spelling out 'Baker' have been removed to reveal the lower half of the figures.

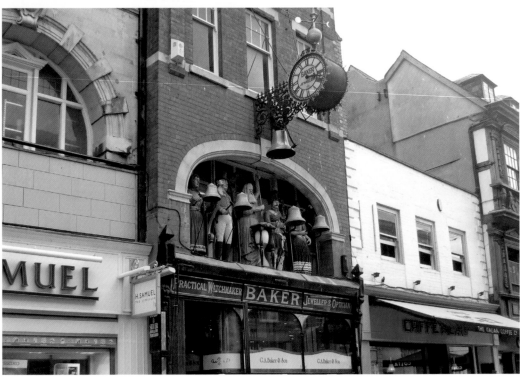

### City Tea Warehouse

This property dates from 1665 and was built for apothecary Thomas Yate. It has been suggested that the timbers used for the ornate Jacobean façade may have come from seventeenth-century ship the *Mayflower*. The building was used as a tobacconist's shop, which was known locally as the 'Old Blue Shop' in reference to the blue paint used on its frontage. As you can see above, the property later became the City Tea Warehouse, belonging to tea merchant Mr Clark. This impressive building is ironically now occupied by a Costa coffee shop! To the right of the photograph you can just make out the edge of the Bell Inn, which was demolished in 1967, to make way for the Eastgate Shopping Centre.

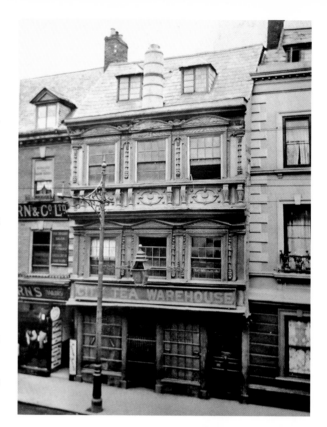

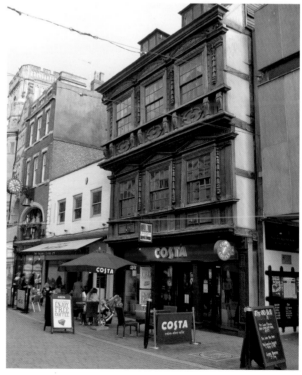

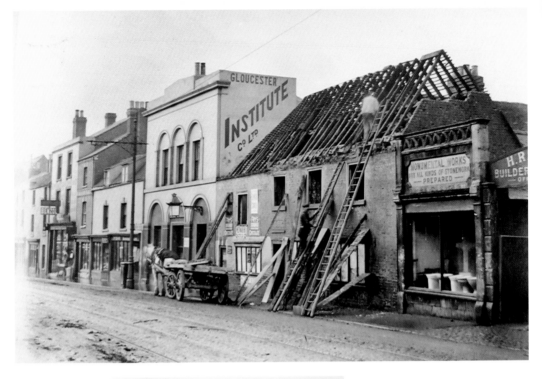

## No. 54–55 Southgate Street

The photograph above shows builders demolishing Nos 54–55 Southgate Street. Today the horse and cart and wooden ladders have been replaced by mechanical diggers and 'cherry pickers'. The photograph below shows what remained of Northgate Mansions after the collapse of the front wall following heavy snowfall in 2010/11.

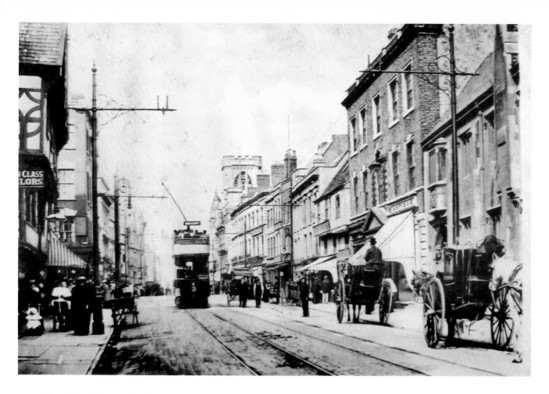

## Looking Towards the Cross

This view, taken looking towards the Cross, shows a busy street scene with horses still a prominent feature. In the distance to the right is the Bell Hotel. The Bell Inn was immortalised in Fielding's book *The History of Tom Jones a Foundling*, and in 1714 was the birthplace of Methodist preacher George Whitfield. Thomas Whitfield, his father, was the landlord of the popular inn that existed on the site from 1544 to 1973 when it was demolished.

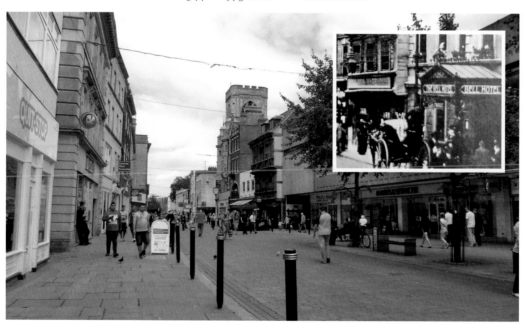

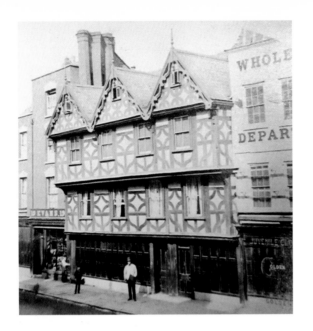
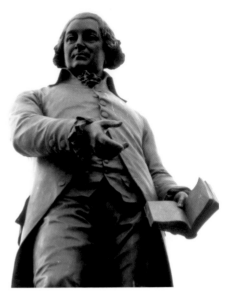

## Robert Raikes' House

The building popularly referred to as Robert Raikes' House dates from 1560 and was originally a merchant's house. Robert Raikes, pictured above, was the founder of the Sunday School movement and editor of the *Gloucester Journal*. He published the *Journal* from this house in 1758 and later resided there. The property became the Golden Cross pub but in 2008 was reopened with the new name of Robert Raikes' House, following a renovation project, which restored this Tudor building to its previous splendour.

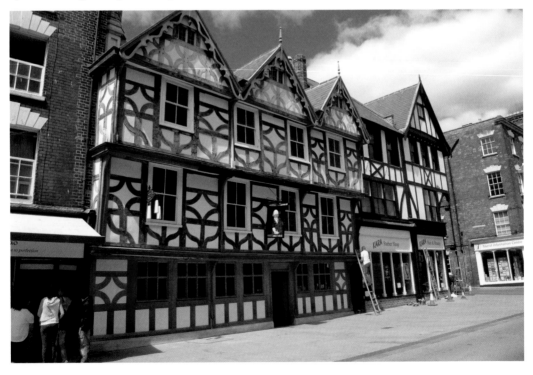

## St Mary de Crypt

St Mary de Crypt, a fascinating fifteenth-century church tucked away off Southgate Street, can boast many famous connections. The Methodist preacher George Whitfield delivered his first sermon here after being ordained. Robert Raikes was christened and buried at St Mary's, as was Jemmy Wood, the infamous banker who inspired Dickens's character Scrooge. The tower originally had four pinnacles, which were removed in 1908, and the church was used during the Civil War to store ammunition. On part of the burial ground is the Crypt schoolroom, which was built in 1539 by John Cooke to provide free education.

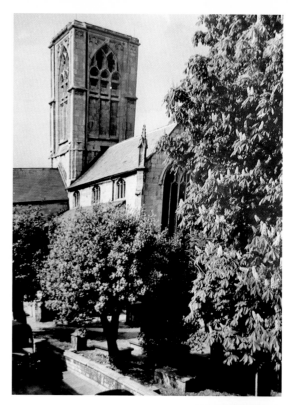

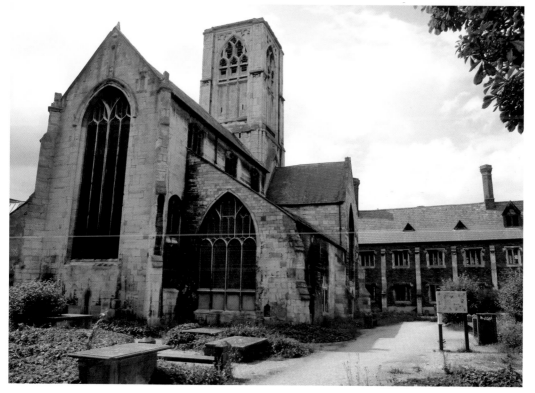

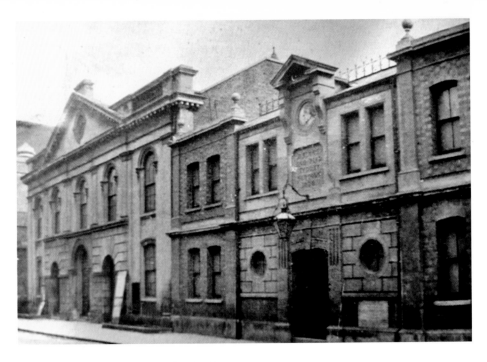

**Brunswick Baptist Church and School**

Above is the Brunswick Baptist Church and school taken in 1900. It was erected in 1873 on the site of a previous chapel and the adjoining schoolroom was built in 1884 as a memorial to Robert Raikes. Below, a very different style of architecture was used for the modern-day Brunswick Baptist church located in Southgate Street.

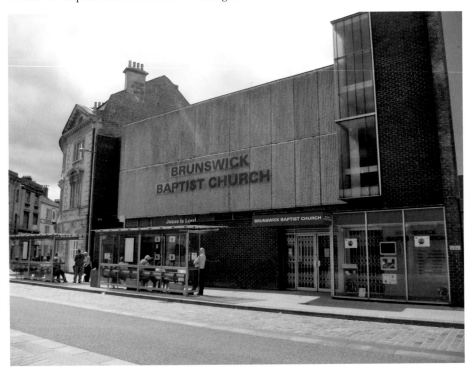

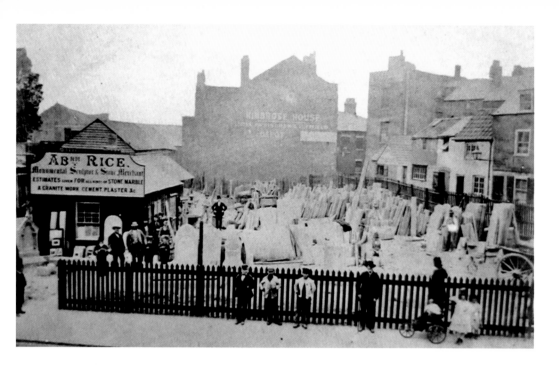

## Kimbrose Triangle

The image above shows the yard of Abraham Rice, monumental stone mason. In the background is Kimbrose House and in the foreground, by the railings, an unusual three-wheeled pram. The image below shows the new railings that have been installed in the Kimbrose Triangle area to follow the same path as the old Roman wall. The name Kimbrose is a derivative of Kyneburgh. Gloucester has two famous Kyneburghs; one was an Abbess of St Peter's Abbey, and the other a virgin martyr who was murdered by being thrown down a well.

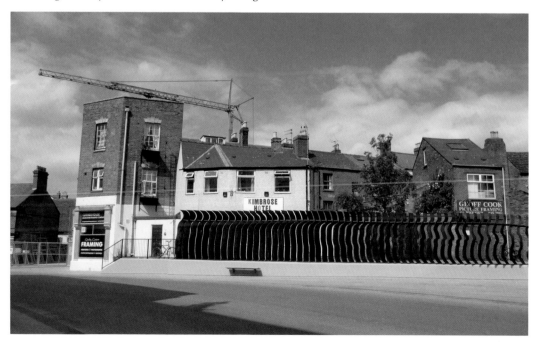

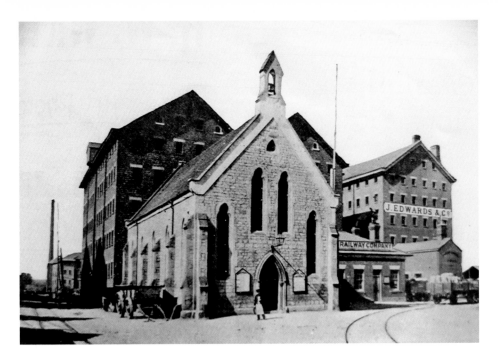

### Mariners' Chapel

The Mariners' chapel opened in 1849 and was created to cater for the crews of visiting ships, whose clothes were considered inappropriate for worship in city churches. During the first part of the 1800s, the docks would close on a Sunday so open-air services were held for the many people living on the boats in the barge basin. The chapel was built up against the Reynolds Warehouse, which was erected in 1840 to store corn. The Railway Company building has since been demolished and Reynolds Warehouse was converted into flats as part of the regeneration project. Stained-glass windows were added to the chapel in the 1920s, and local poet Ivor Gurney was supposedly the chapel organist for a time.

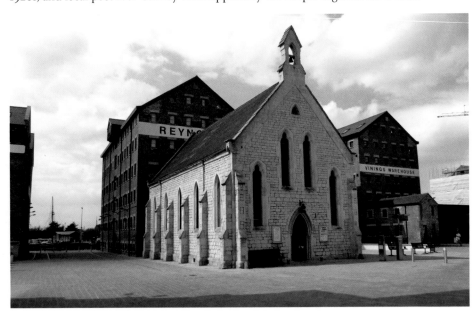

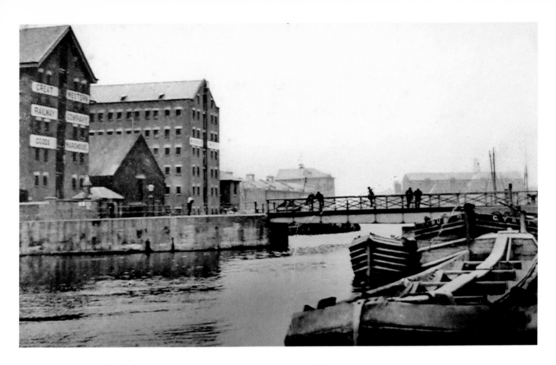

### Llanthony Bridge

Today Llanthony Bridge looks somewhat altered from the original photograph, with its large metal-lifting mechanism dominating the skyline above. The original swing bridge was installed in 1862 and later replaced by the present lift bridge in the 1970s. The warehouses to the left are Alexandra Warehouse, which was built in 1870 for J. E. & S. H. Fox, and the Great Western Railway warehouse, which has been demolished in the intervening time.

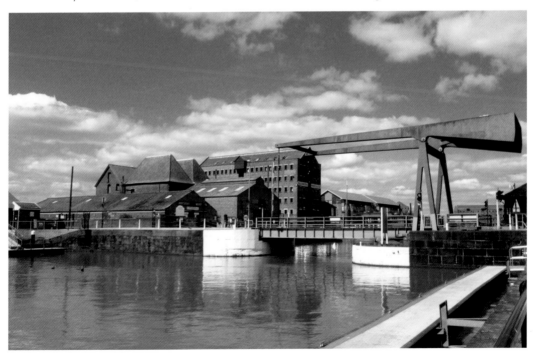

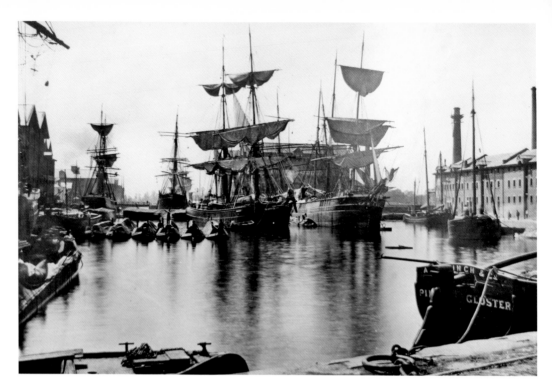

## Tall Ships

The main basin was opened in 1812 to allow coal transportation from the Forest of Dean, but it wasn't until the canal opened in 1827 that Gloucester became a thriving commercial port. A second basin was built in 1849 and the docks boasted a building yard and dry dock. The photograph above shows the main basin filled with sailing vessels and was taken from North Quay in 1883. The annual Tall Ships Festival, pictured below, sees Gloucester once more filled with these magnificent ships and gives an idea of how the docks would once have looked in its heyday.

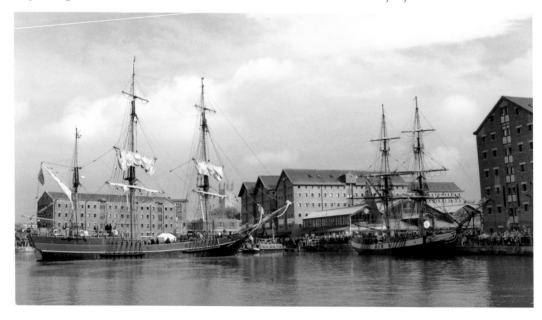

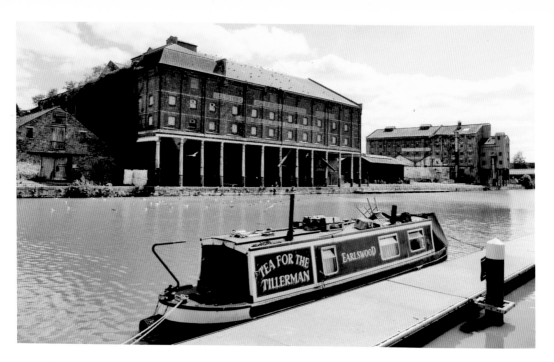

## Pillar Warehouse

Built in 1838, the unusual design of the Pillar Warehouse allowed goods to be hoisted directly from the ship's hold. Home to Onedin's Restaurant in the 1970s and the City Barge pub during the 1980s and 1990s, part of the building was later converted into offices. A warehouse of similar construction further down the quay has since fallen into disrepair and is seemingly held together merely by rust. I have often enjoyed sitting by the moorings opposite these two contrasting buildings, watching the gulls on the wing.

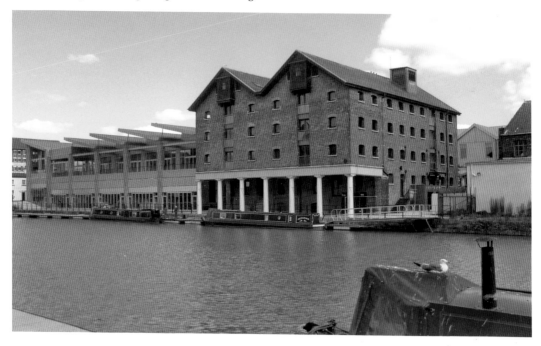

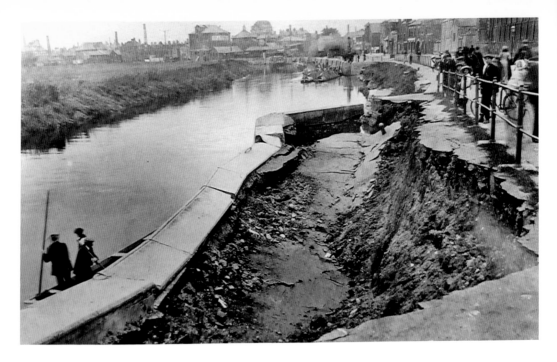

## Wing Wall Collapse

The report read as follows: 'A slight crack, fist noticed along the back of the wall at 6am on Saturday 7th September, 1912. The wall, 100 foot in length, commenced to slide bodily into the river foot first at 9am the same day and continued to slide until about 10:30am when the movement stopped, and remained as photographed above.' Gloucester Prison can be seen to the right of the photograph and I'm sure health and safety wouldn't allow passing boats to get so near to a subsiding wall these days!

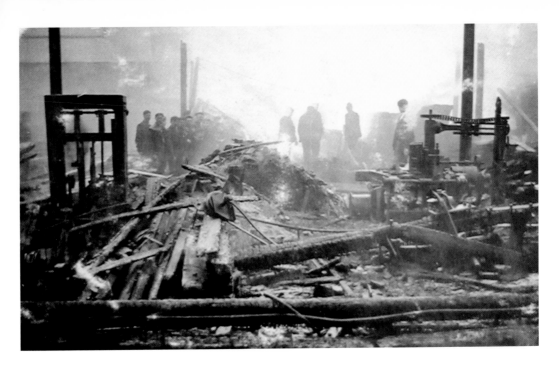

### Nick's Timber Yard

The photograph above shows the aftermath of a fire at Nick's Timber Yard in 1907. A fire-float called the *Salamander* and the city fire brigade were called to help extinguish the blaze at Nick's Saw Mill. It had soon spread to the stacks of timber in the yard causing a huge blaze. The timber trade was very important to the area so a special timber pond, linked to the canal, was created south of Monks Meadow. Nick's Timber Yard in the Bristol Road is pictured today below.

**Llanthony Secunda Priory**
Built in the Black Mountains of Wales in 1136, the original Llanthony Priory came under attack from Welsh rebel forces, causing the canons to flee to Gloucester. The Gloucester Augustian Priory was completed in 1150 and became one of the richest monasteries in Medieval England, renowned for its hospitality. Sadly, not much remains today, but on the six bays of the west range that still stand, a timber-framed first floor added in the fifteenth century is clearly visible. The photograph below also shows the late-nineteenth-century addition of a small farmhouse.

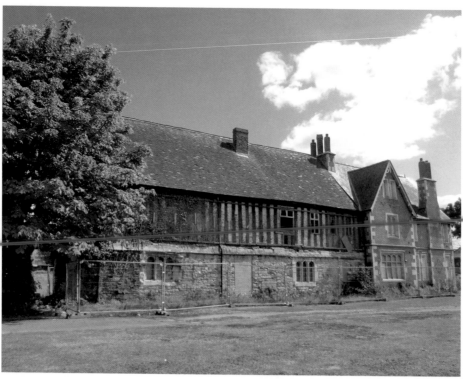

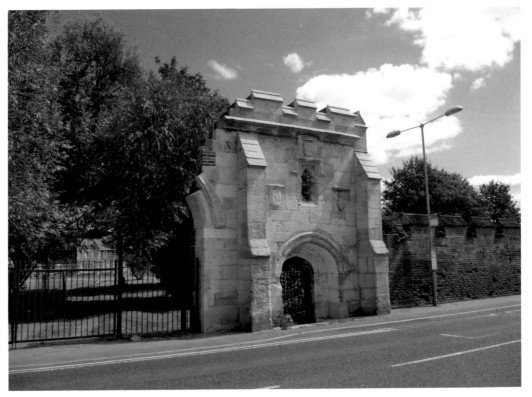

## Llanthony Remains

This photograph was taken in 1899 outside the gateway to Llanthony Priory. It dates from the fifteenth century and would have given access to a brewery, bakery and dairy; the small window above the archway would have been the location of the gamekeeper's chamber. Used for arable farming and then later cattle production, the site originally extended to the other side of the canal, where the Priory's church was located, before being cleaved in two by the building of the canal in the 1700s.

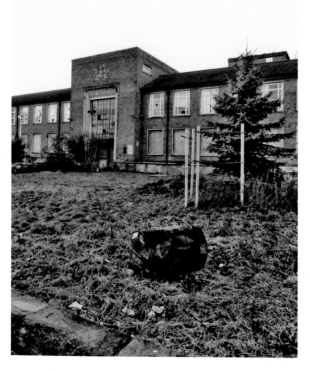

## Gloscat

Now known as Gloucestershire College, Gloscat changed premises to a brand new facility at the docks as part of the regeneration project. I studied Music Technology at both the old and new facilities and was one of the first years to experience the new building in Llanthony Road. The old Gloscat campus, located in Brunswick Road, was split across two locations; the main campus, pictured above, and the Media Campus, which was partially burned down in the riots of 2011. Whilst the new campus continues to thrive, plans for redevelopment are sorely needed in the pocket of urban decay it left behind.

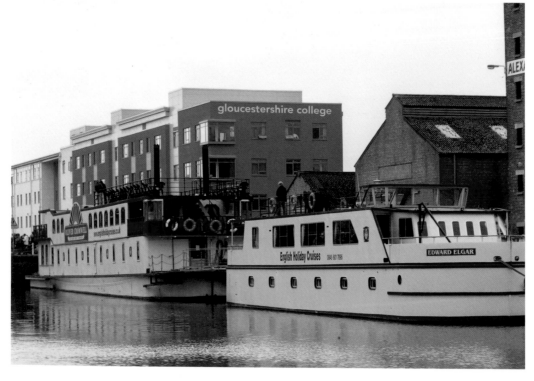

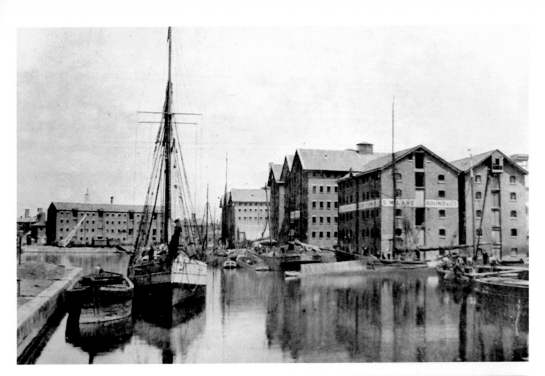

## Gloucester Quays

Regeneration is very much the next chapter in Gloucester's history and the changes that have occurred have radically transformed this area. This pair of photographs, although taken of different views, illustrates two distinctive and contrasting scenes of past and present. The photograph below shows the entrance to the new Gloucester Quays designer outlet, taken near the antiques centre, which relocated from the Lock Warehouse. The new outlet is intended to attract more people to the area and establish Gloucester as a place for retail as well as tourism. 'Blackfriars' is scheduled to be the next area to emerge from regeneration, and is set to be 'the new cultural and creative heart of the expanded city centre'. The shops, hotel and revitalised Blackfriars Priory are eagerly awaited at the time of writing.

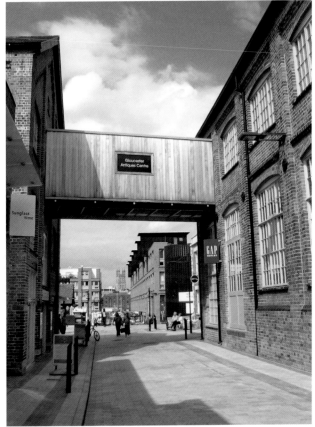

**The Storyteller Bench**
Tucked away off Southgate Street by the back of the Eastgate shopping centre you will find the Storyteller Bench. Carved by local stone masons, it celebrates the history of Gloucester and offers a pleasant vantage point from which to admire St Mary de Crypt.

# Acknowledgments

I would like say a huge thank you to Lynne Cleaver for recommending me for this book and to the staff at Amberley Publishing. Special thanks goes to all the staff at Gloucestershire Archives, especially Vicky Thorpe, Katrina Kier and Sue Constance who have been very patient and helpful throughout my research. I'd also like to thank the Restoration & Archive Trust for their assistance, Colin Nyland from the Tailor of Gloucester Museum for all his help and Jon Prichard for allowing me to use the photograph of his Grandfather on page 20. My sincerest gratitude goes to the following people for allowing me to use their images in this book: all new images taken by the author except pages 11, 50, 51, 68, 88, 91, 94, which were taken by Steve Standbridge and page 32 by James Timbrell. Old Images on pages 21, 26, 29, 92 were used with kind permission from National Monuments Record (NMR) and all other old images courtesy of Gloucestershire Archives. Every effort has been made to contact copyright holders. If anyone has been inadvertently overlooked, please get in touch so we can amend future editions. For more information about the author visit my website at www.regencyresearch.moonfruit.com.